THE HERMITAGE

Masterpieces of the painting collections

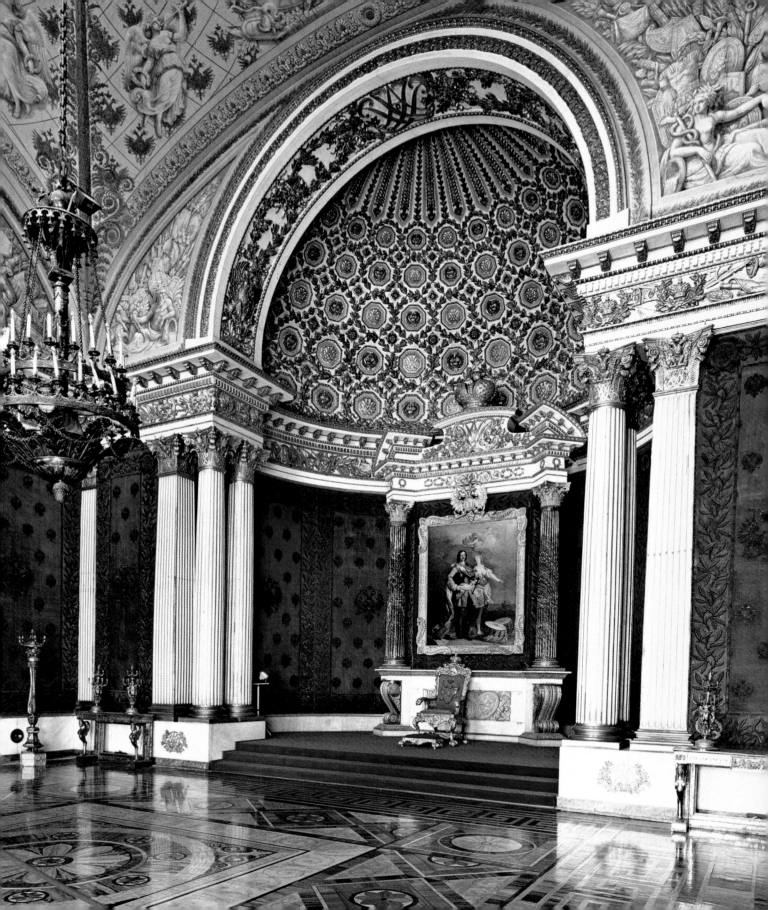

THE HERMITAGE

Masterpieces of the painting collections

SCALA

Photographs © State Hermitage, 2004
Texts © Scala Publishers, London, 2004
Preface © Mikhail Piotrovsky

First published in 2004 by Scala Publishers Ltd
in association with Slavia Publishers, St Petersburg

Scala Publishers Ltd
Northburgh House
10 Northburgh Street
London EC1V OAT

ISBN 1 85759 282 4 (trade UK)
ISBN 5-9501-0057-3 (trade Russia)

Designed by Anikst Design
Printed and bound in Italy

All the paintings in this book were reproduced
from transparencies belonging to the State Hermitage,
except:
Claude Gellée (Lorrain), *Morning in a Harbour* and
Cézanne, *Still Life with Drapery* © Bridgeman Art
Library

Hermitage photographers:
V.S. Terebenin, L.G. Kheyfets, Yu.A Molodkovets,
S.V. Suyetova, K.V. Sinyavsky

The following paintings were reproduced with
permission:

Dance, 1910; *The Artist's Family*, 1911
© Succession H Matisse/DACS 2004

Boy With A Dog; *Guitar and Violin*, 1913; *The Absinthe
Drinker*, 1901; *Woman with a Fan*, 1908
© Succession Picasso/DACS 2004

Front cover illustration:
Leonardo da Vinci, detail of *Madonna and Child*
(*Litta Madonna*), 1490–91

Previous page:
*Petrovsky's (Peter I's), or the Small Throne, Room, created in
1833 by the architect Auguste Montferrand and dedicated to the
memory of Peter the Great.*

CONTENTS

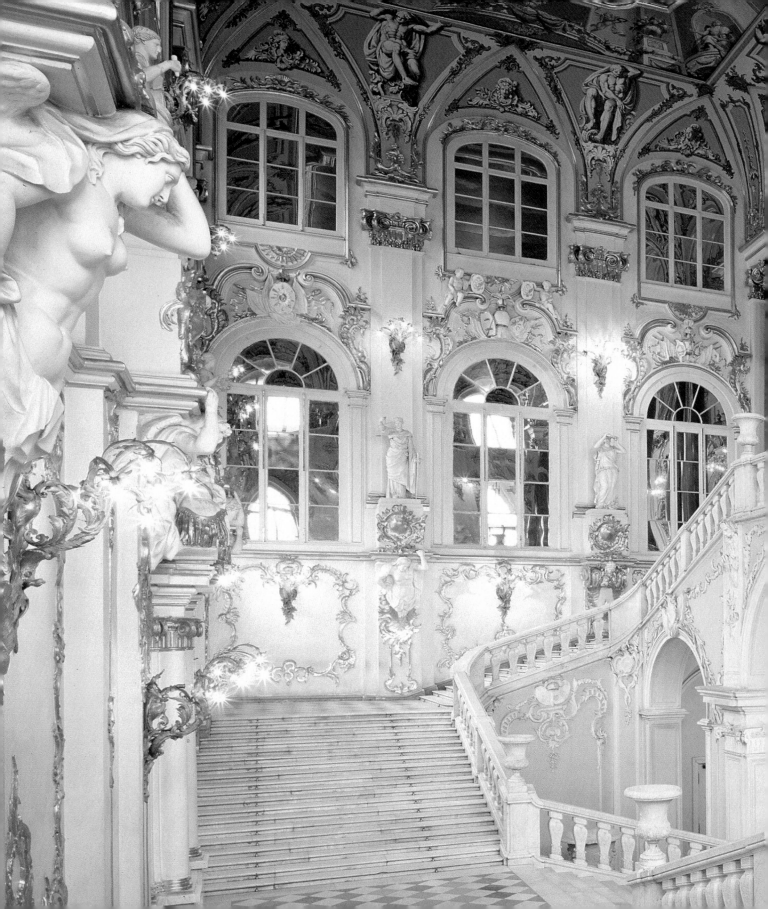

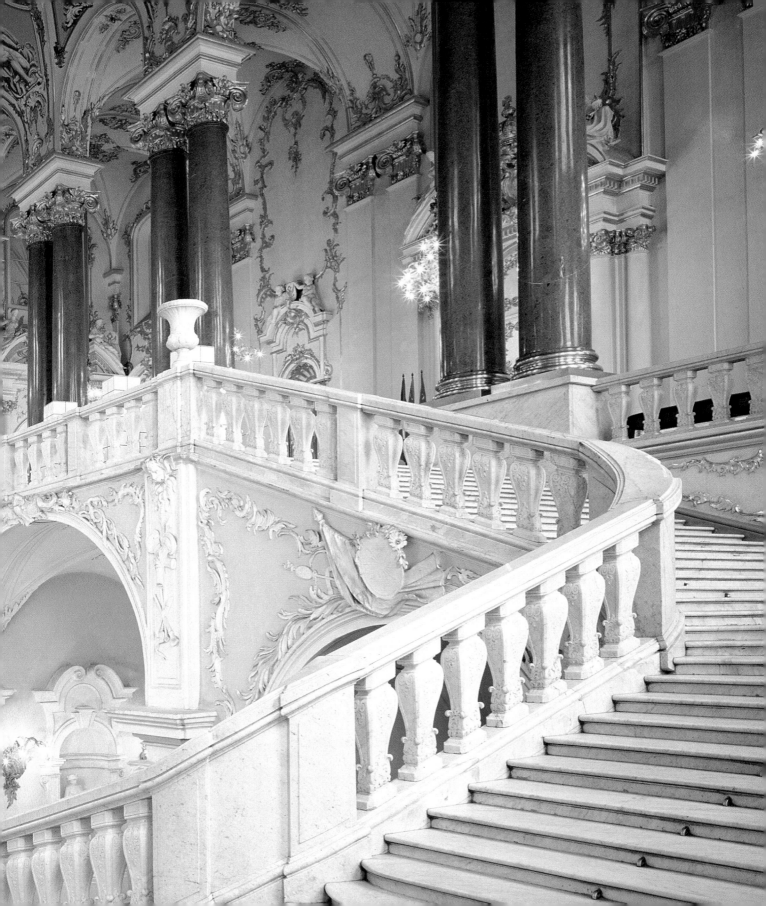

PREFACE

The Hermitage is a celebrated museum, the pride of Russia and her northern capital, St Petersburg. The Hermitage houses more than three and a half million monuments of art and culture. These include paintings, sculptures, drawings and engravings, the richest collection of works of the applied arts and more than one million coins and medals and archaeological and cultural artefacts. In the Hermitage the entire history of culture and art of the peoples of Europe and the East from prehistory until the twentieth century unfold before the visitor. The Hermitage occupies five buildings in the centre of St Petersburg, and is one of the city's most beautiful architectural ensembles. It includes the Winter Palace, the former residence of the Russian emperors, the Hermitage Theatre and the museum buildings proper – the Small, Old and New Hermitages.

The museum was initiated in 1764 when Empress Catherine II bought the Berlin merchant Johann Ernest Gotzkowski's collection of 225 paintings. She made it her goal to establish her own palace gallery which would possess collections no less famous than those of European monarchs. On her instruction, through the intermediaries of the best art connoisseurs of the time, entire collections, as well as individual works of art, were purchased at European auctions; and commissions were made from prominent artists. The Empress gave herself up with passion to collecting – by her own admission she suffered from the "gemstone sickness". Towards the close of Catherine II's reign the Hermitage collection numbered 3,000 paintings, almost 7,000 drawings and more than 70,000 engravings as well as 10,000 carved stones and 38,000 books. Already at that time the Hermitage was considered to possess one of the richest palatial collections in Europe. In the era following the reign of Catherine the Great, additions to the Hermitage became more and more purposeful: the museum acquired monuments of art which were needed to provide a comprehensive reflection of the history of art. Thus in the 1830s–1860s antique relics were actively purchased in Europe; in the 1830s archaeological research began in southern Russia and the Hermitage was enriched with valuable works of ancient Greek and Scythian art. The largest acquisition during these years, however, was the collection of the Marquis of Campana by Alexander II in 1861. A private palace museum under Catherine II, the Hermitage had been

Previous page:
The Main, or Jordan, Staircase built by Francesco Bartolomeo Rastrelli in 1756–61. Restored after the great fire of 1837 by Vassili Stassov.

transformed into the most outstanding European museum of world art by the mid-nineteenth century.

The immense palace of the Russian emperors, built in the eighteenth-century Baroque style, is a majestic and elegant edifice. Its southern façade, with wide patterned cast-iron gates, mighty columns spanning two stories and sculptures over the cornice, faces Dvortsovaya (Palace) Square. The northern façade's high porch stretches along the Neva, with its rhythm of snow-white columns echoing the coursing of the river's waves. The western and eastern façades with their rizalites are turned towards the city: the eastern part is hidden behind the Small Hermitage adhering to it, while the western façade, concealing a small, charming garden, looks onto the ancient Admiralty building. At the time of the erection of St Petersburg in the early eighteenth century, the grand residences of dignitaries, and that of the founder of the city, the Emperor Peter I, stood on this site. Empress Anna Ioannovna settled in one of these palaces in the early 1730s. Her successors also chose to live here during the winters. Russian power grew and expanded; the might of Russian monarchs intensified and, in 1754–62, on the site of the decayed old "Winter Residence", the chief architect of the Russian court, Francesco Bartholomeo Rastrelli, build a new Winter Palace – one corresponding to the dignity and brilliance of the Russian autocracy.

The 1917 revolution transformed the Imperial Hermitage into the State Hermitage. During most of the twentieth century the museum collections expanded almost fourfold. In the first years following the revolution, lavish private art collections, nationalised by the Soviet government, went to the Hermitage. In the 1930s and 1940s a number of museums in the city, then called Leningrad, and in Moscow were closed by the government; their collections, French paintings of the nineteenth and twentieth centuries, for example, found refuge in the Hermitage. Another source of additions were the constant scientific and archaeological expeditions, which brought in collections of Scythian antiquities, ancient Altai art, old Russian icons, monuments of art from Central Asia, China and Tibet, and much more. Works of art, acquired through the Hermitage Purchasing Commission, at international auctions and presented by collectors and contemporary artists, merged with the Hermitage collection. The departments of

Western European Art, Ancient World and Numismatics had been established in the eighteenth and nineteenth centuries. The Oriental Department was founded in 1920; the Department of Archaeology in 1931 and the Department of the History of Russian Culture ten years later.

The Hermitage did not remain untouched by the terrible ordeals which befell Russia in the twentieth century. At the end of the 1920s–early 1930s the museum lost part of its treasures, which, following an unfortunate governmental decree, were sold to foreign buyers. More than fifty major works of art, amongst which Raphael's *Madonna Alba*, Titian's *Venus with a Mirror*, Rubens's portraits of Isabella Brant and Elena Fourman (the renowned *Fur Coat*), Rembrandt's *Portrait of Titus*, Watteau's *Mezzetin*, are now in museums in Europe and the United States.

During World War II the Hermitage experienced all the tribulations of Leningrad's nine hundred-day blockade. The museum's most prized collections (over a million pieces) were evacuated, accompanied by their curators, to Sverdlovsk (now called Yekaterinburg, as it was before the revolution) in the Urals. The few museum employees who chose to stay in the museum courageously attempted to safeguard the remaining exhibits from bombardment and shelling, and the deserted halls and buildings from dampness, snow and rain. Dying from cold and hunger in the besieged city, scholars from the Hermitage did not, however, cease their work. The war ended, the collections were brought back from exile – not a single work of art had been lost – and over the following years, the restored halls began to radiate beauty again. Nearly sixty years have already passed since that tragic time, which the Hermitage has spent collecting, restoring, safeguarding, studying, exhibiting – the routine life of the magnificent museum it is.

Dr Mikhail Piotrovsky
Director of the State Hermitage

Right:
One of the most lavishly decorated rooms of the Winter Place, the Malachite Drawing-Room.

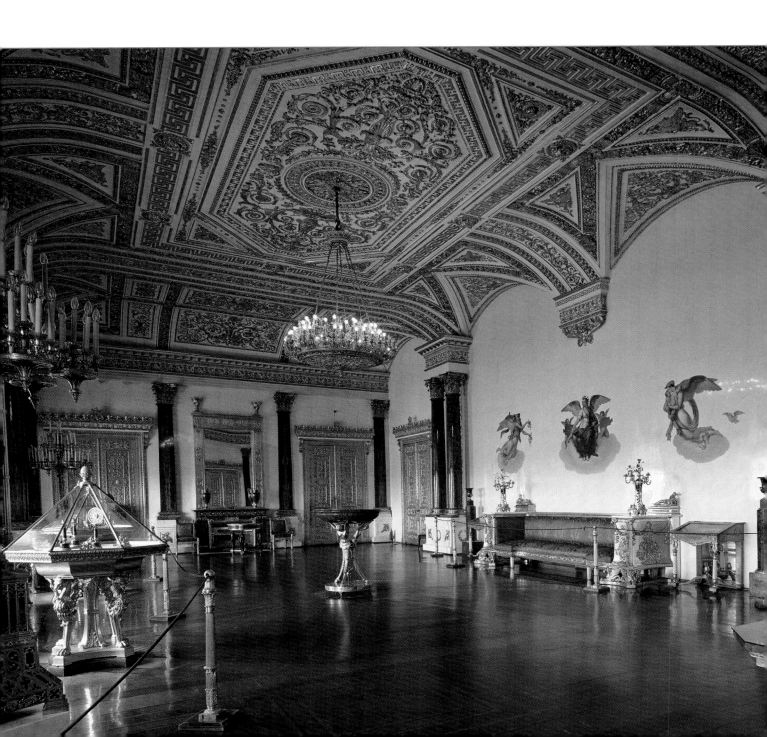

A SHORT HISTORY OF THE MUSEUM

The foundation of the Hermitage is usually given as 1764, when Catherine the Great acquired the collection of Berlin merchant Johann Gotzkowsky. However one could trace the Hermitage's origins a little further back to 1704 and the foundation of Peter the Great's Kunstkammer. Indeed, Peter I was, before Catherine II, Russia's most assiduous collector. The Kunstkammer, then housed in a pavilion adjoining the small wooden summer palace on the Neva, was Russia's first museum and one of the earliest in the world. The purpose of this gallery of curiosities (or monstrosities, according to his subjects) was to collect and study natural and human rarities. But Peter the Great was an art lover with prolific and eclectic tastes: the Kunstkammer also exhibited pieces of Scythian gold – still among the most popular exhibits in the Hermitage. Rembrandt's great painting of *David parting from Jonathan* was acquired by him in Holland in 1716, and the *Tauride Venus*, unearthed in Rome in 1718, was carried to Russia on his orders in a specially constructed sprung wagon.

However it is Catherine the Great who was the presiding genius of the Hermitage museum. Using such figures from the Age of Enlightenment as Diderot and Voltaire's friend, Melchior Grimm, as agents, the empress bought not just great individual works such as Michelangelo's *Crouching Boy* and Houdon's *Voltaire*, but whole collections. Five years after buying the Gotzkowsky collection, Catherine bought, in Dresden, over 600 Flemish, Dutch, Italian, German and French pictures from the heirs of Augustus the Strong's chancellor, Count von Bruhl; from the heirs of the Parisian banker Pierre Crozat, in 1772, she bought 400 paintings – one of the most celebrated collections of the early eighteenth century that included Raphael's *Holy Family*, Giorgione's *Judith*, and one of the most admired paintings in the Hermitage, Rembrandt's *Danae*. The year 1779 saw one of the most important acquisitions ever made for the Hermitage, the pictures of Sir Robert Walpole, Britain's first Prime Minister. They consisted of 198 works by Rubens, Van Dyck, Murillo, Rembrandt, Poussin, Snyders and others.

The Hermitage owes its fame and popularity primarily to its picture collections. The museum contains outstanding Italian paintings from the thirteenth to the eighteenth centuries, with works by Simone Martini, Fra Angelico, Filippo Lippi and Botticelli; two of the twelve undisputed paintings by Leonardo da Vinci are in the Hermitage; the richness of the Venetian section, which comprises 300 of the 1,091 Italian paintings in the museum – and no less than twelve Titians – is such that it is possible to trace the entire history of Venetian painting.

Peter the Great

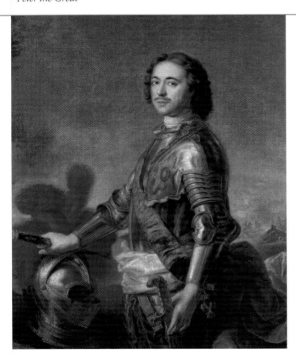

Mercantile, maritime Holland had greatly attracted and influenced Peter the Great and it is perhaps no surprise that the Hermitage contains one of the largest and most comprehensive collections of Dutch art of the Golden Age outside Holland, as well as a tremendous number of Flemish works, including almost 40 paintings by Rubens and 24 by Van Dyck.

The Spanish and French holdings are similarly outstanding: Velázquez, Ribera, Zurbarán, El Greco and Murillo in the former, Le Nain, Claude, Poussin and a wonderful collection of eighteenth-century painting, the jewels of which are two magnificent works by Watteau. And, of course, there is the astonishing collection of French Impressionist and Post-Impressionist paintings assembled by the rich merchants Sergei Shchukin and Ivan Morozov, and confiscated at the revolution. The collection, consisting of 348 works by the world's best-known painters, Monet, Renoir, Cézanne, Gauguin, Bonnard, Matisse and Picasso, was divided between the Hermitage and the Pushkin Museum in Moscow.

Catherine the Great's collections were originally all housed in the Winter Palace, the

Catherine the Great
(unknown artist)

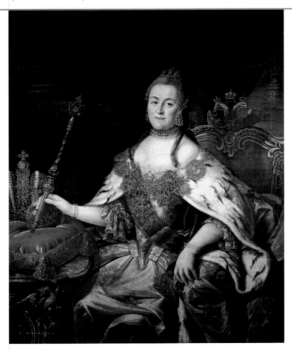

principal palace of the Russian tsars, built between 1754 and 1762 by Rastrelli on the Neva.
To this were soon added, as the collections grew, the Little Hermitage (1764–75, architects
Yuri Velten and Jean-Baptiste Vallin de la Mothe), the Old Hermitage (1771–87, architect Yuri
Velten) and the Hermitage Theatre (1783–1789, architect Giacomo Quarenghi). Catherine
used the Hermitage as a club, where she constantly gave dinners. Among the rules she had
mounted on the wall were:

"1. All ranks shall be left behind at the doors, as well as swords and hats.

2. Parochialism and ambitions shall also be left behind at the doors."

While foreigners were already admitted in Catherine's day, it was her favourite grandson,
Alexander I, who formally turned the Hermitage into a museum. The collections continued
to grow and were constantly enriched. Alexander even managed to secure the services of
Baron Dominique-Vivant Denon, the first director of the newly opened Louvre, as agent,
and Denon bought Caravaggio's *Lute Player* for the Hermitage. The fall of Napoleon gave

Alexander further opportunities, and after Josephine's death – Josephine had already given him the famous Gonzago cameo – Alexander bought the 38 paintings that had originally come from the Kassel Gallery, trophy pieces seized by Napoleon and presented to his wife as a gift, and which included four of Claude's finest landscapes. It was Alexander, too, who commissioned from the English painter, George Dawes, the portraits hanging in the specially designed '1812 War Gallery', a magnificent memorial to Russia's military glory.

Nicholas I, Alexander's brother, who reigned from 1825 to 1855, was the last tsar to affect profoundly the evolution of the Hermitage. In December 1837 the Winter Palace was gutted by fire; Nicholas took a keen interest in its reconstruction, completed in just 18 months by 8,000 workmen working day and night (Rastrelli had taken 8 years); it was he, too, who insisted that the principal state rooms be reinstated as they had been. He commissioned the German architect Leo von Klenze, who had designed the Glyptothek and Alte Pinakothek in Munich, to draw up plans for an extension to the existing Hermitage – the New Hermitage, built in a Historicist style and skilfully tucked in between the Little and Old Hermitages, opened in 1852. Not all Nicholas' interventions were so successful, however. He sold some 1,220 paintings he didn't like and dismissed Houdon's great statue of the seated Voltaire with the words: "Destroy this old monkey". Fortunately, his orders were ignored.

While the 1917 revolution brought in many more paintings from nationalised private collections, between 1928 and 1934 Stalin sold several thousand works of art from the Hermitage, including some 25 world-class paintings to collectors such as J. P. Morgan and Calouste Gulbenkian. Although the threat of far greater sales was very real, such is the size and quality of the Hermitage collections that the damage was relatively limited. Today the museum houses more than three and a half million exhibits spanning millennia of world history, and displayed in more than three hundred rooms – a captivating and infinite source of knowledge.

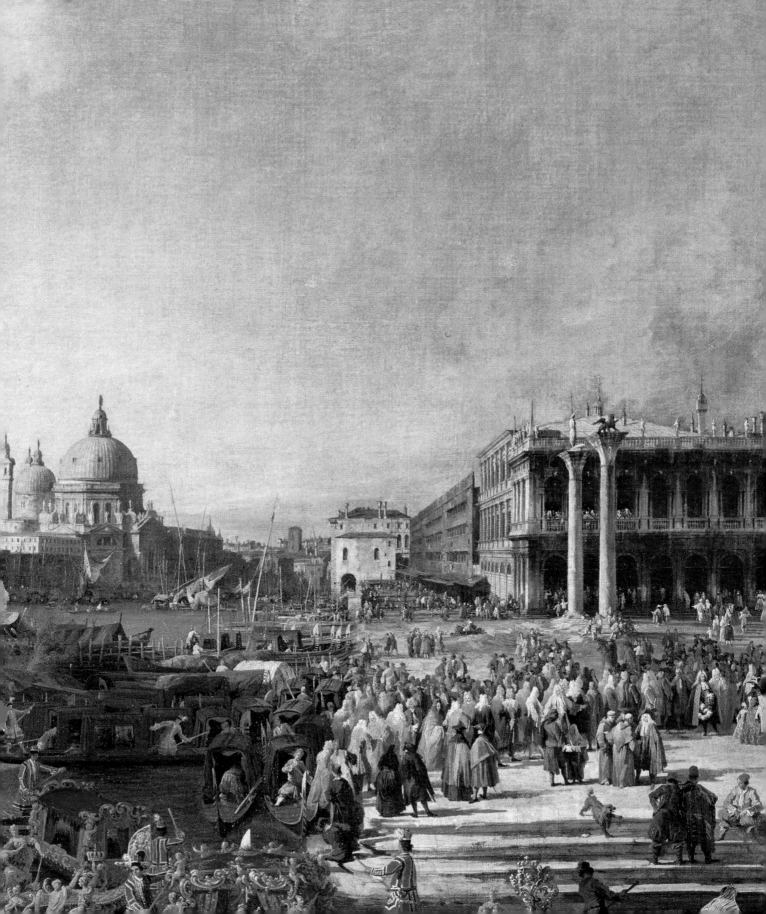

ITALIAN PAINTING

Canaletto,
Reception of the French Ambassador in Venice,
1725–26

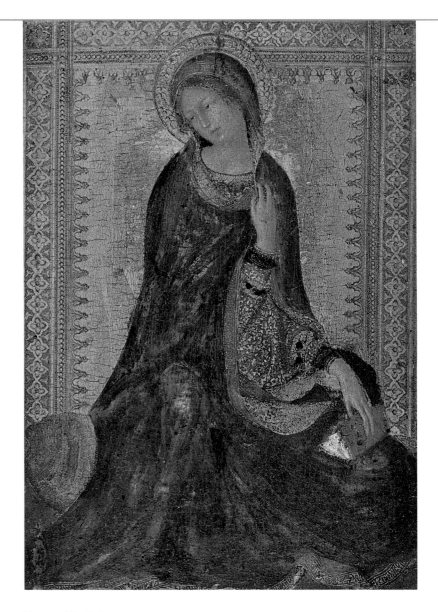

Simone Martini
c.1284–1344
Italy; Sienese school
Madonna of the Annunciation, 1340–44
Tempera on panel, 30 × 21.5 cm
From the Grigory Stroganov
collection, Rome; presented
by the heirs in 1911

(Left) One of the Hermitage masterpieces, the *Madonna of the Annunciation* was painted in his late years by Simone Martini. Martini, one of the leading painters from Sienna and a pupil of the Duccio, produced this work during his time in Avignon working at the papal court.

The Madonna forms the right panel of a folding diptych – the left leaf, showing the Archangel Gabriel, is in the National Gallery of Art, Washington D.C. Combining Byzantine tendencies such as gold backgrounds, with simple and elegant Gothic forms, Simone contributed to the development of International Gothic, a style marked by glowing colours, precise lines, a wealth of ornament and graceful, flowing figures. Seated on a cushion, his Madonna is the very embodiment of elegant femininity. Her head is bowed and she listens calmly to the words of the heavenly messenger, telling her that it is her fate to be mother of the Saviour of the human race.

(Right) Fra Angelico, a Dominican monk, only painted subjects of a religious nature and was instrumental in the development of the type of altarpiece that became known as *sacra conversazione*, representing the Madonna with Child surrounded by saints. In this work, Dominic, holding a lily and a book, and Thomas Aquinas, stand on either side of the Madonna. This composition is powerful in its sobriety, and remarkable for its symmetry and harmony of colours; its simple, direct style is more restrained than in most of Angelico's works and without the multitude of colourful details and embellishments usually favoured by the artist. It was painted for the Monastery of San Domenico da Fiesole, near Florence. When the monastery closed down in the 1870s the fresco was rescued by the Florentine artists Alessandro Mazzanti and Cosimo Conti.

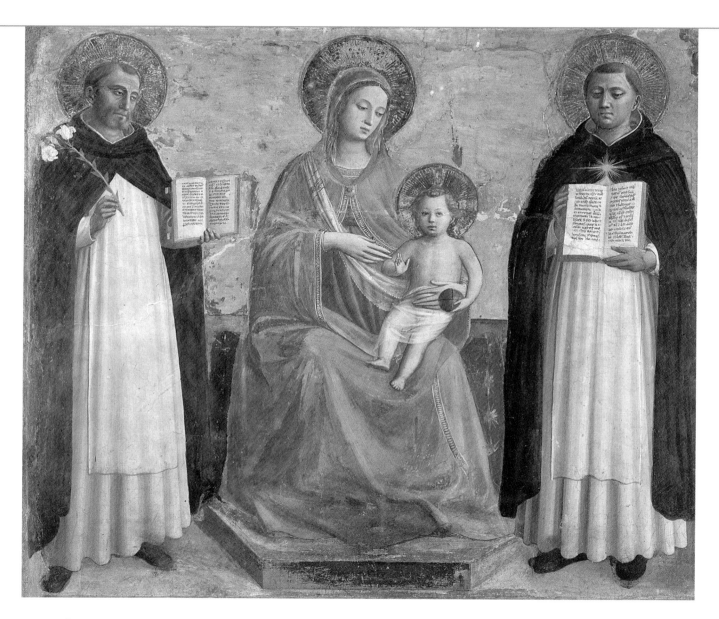

Fra Angelico (Fra Giovanni da Fiesole)
*c.*1400–55
Italy; Florentine school
Madonna and Child with St Dominic
*and St Thomas Aquinas, c.*1430
Fresco, tempera, 196 × 187 cm
Bought from A. Mazzanti and
C. Conti, Florence, 1883

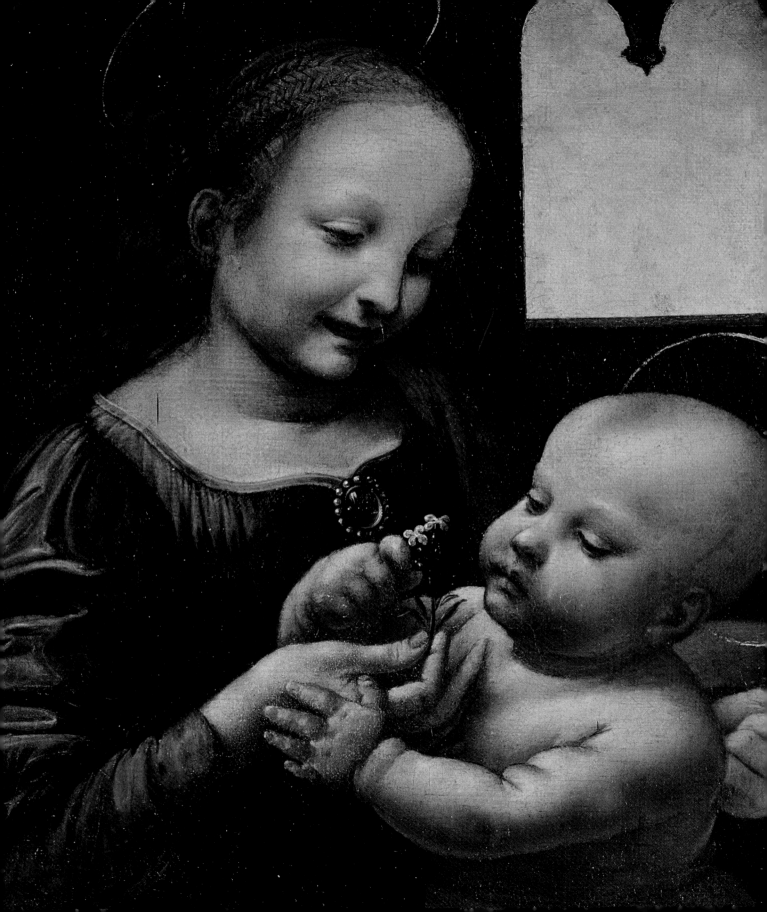

Of just ten or twelve authenticated works by Leonardo known in the world today, the Hermitage possesses two: *Madonna with a Flower,* also known as the *Benois Madonna*, and the *Litta Madonna*. Leonardo greatly favoured the subject of the Madonna and Child. During the early years of his working life he produced several paintings on this theme along with several sketches and a large number of drawings.

The painting shown here is one of the few surviving works by the young artist, and is presented as a genre scene, in which a young mother, shown in the dress and hairstyle fashionable in Leonardo's time, is playing with her son, holding out a four-petalled flower to him. This traditional symbol of the Cross is taken by the child as an innocent toy, which he seeks to grasp in his first attempts to know the world. The warmth of the mother's affection is captured with a remarkable realism, and this gives the painting a sense of freshness and spontaneity. The use of the oil-painting technique – still new in Italy at that time – enabled Leonardo to achieve depth and intensity of colouring as well as transparency in the effects of light and shade.

Leonardo da Vinci
1452–1519
Italy; Florentine school
Madonna with a Flower
(*Benois Madonna*), 1478–80
Oil on canvas (transferred
from panel), 49.5 × 33 cm
From the Maria and Leonty
Benois collection

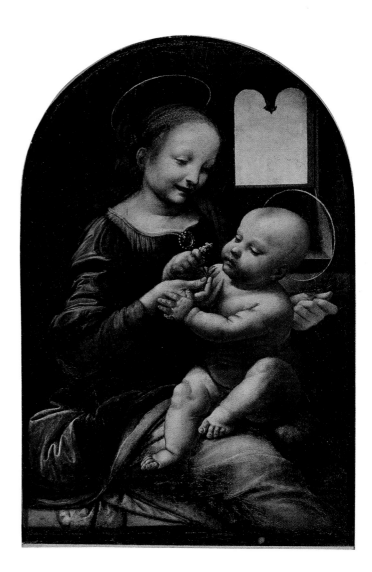

The second of Leonardo's Madonna housed in the Hermitage
was probably painted in Milan, where the artist moved in 1482
to work for Duke Lodovico Sforza and his court. A preparatory
drawing of the Virgin's head can be seen in the Louvre Museum
in Paris, and a comparison with the final painting shows how
Leonardo transformed the figure of Mary into an idealised image
of the Madonna, far from the genre scene depicted in the *Benois
Madonna* (see previous page). Here the beautiful woman feeding
her child seems to be the epitome of motherhood and motherly
love, a quality perceived at the time as perhaps the greatest
human value. Her sublime, serene gaze as she looks at her son,
and the tranquillity of the mountainous landscape – beyond
symmetrical windows – reflect the humanist dream of an Ideal
Man and a Harmonious Life. Modelled in chiaroscuro, the body
of the child looks almost tangible, his intent gaze leaping out
beyond the boundaries of the picture itself as the child looks
directly towards the spectator. It is considered that the *Litta
Madonna* was one the works that heralded the arrival of a new
period in art: the High Renaissance.

Leonardo da Vinci
1452–1519
Italy; Florentine school
Madonna and Child
(*Litta Madonna*), 1490–91
Tempera on canvas
(transferred from panel),
42 × 33 cm
From the Count of Litta
collection, Milan, 1865

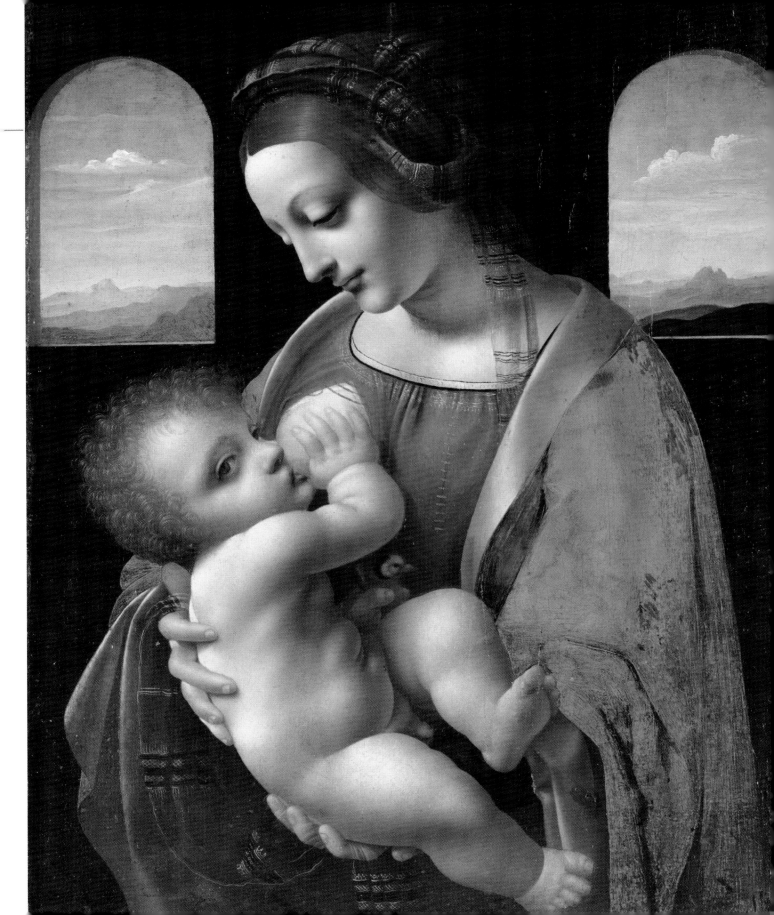

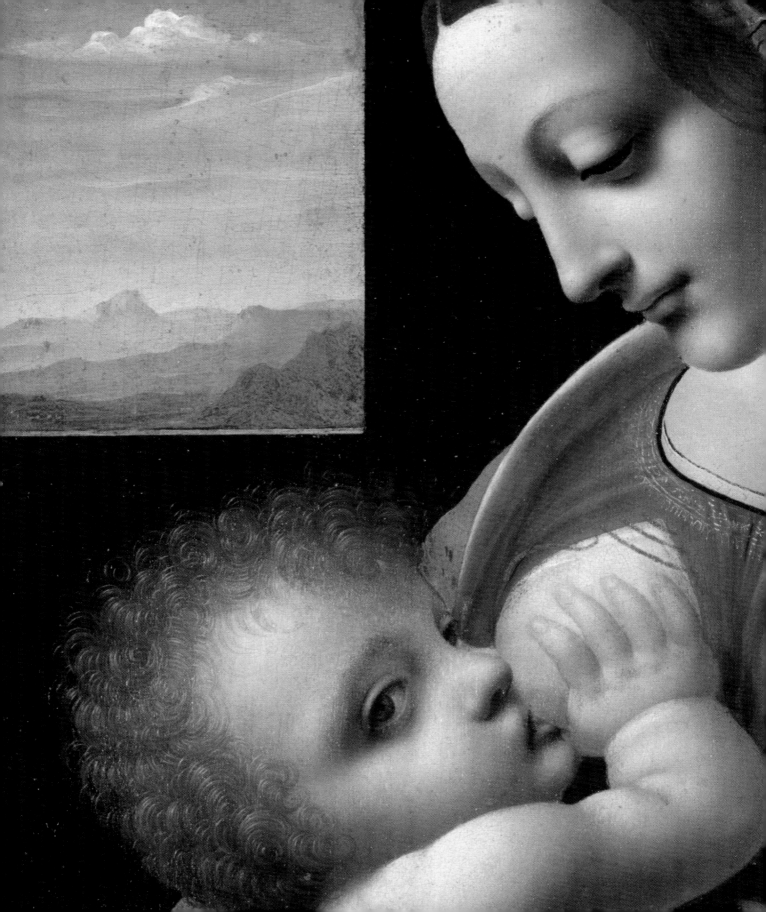

**Cima da Conegliano
(Giovanni Battista Cima)**
*c.*1459–*c.*1517
Italy; Venetian school
The Annunciation, 1495
Tempera and oil on canvas
(transferred from panel),
136 × 107 cm
From the Golitsyn Museum,
Moscow, 1886

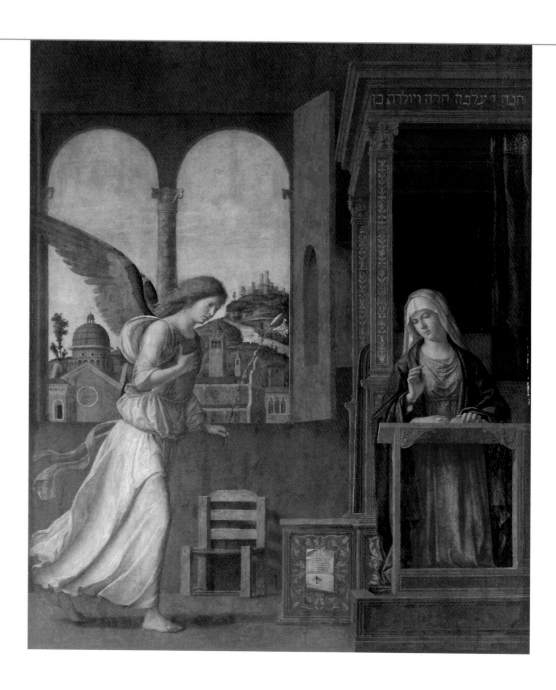

(Left) This panel is the centre part of a triptych that was once kept in Santa Maria dei Crocefieri in Venice, where Cima spent most of his life. Exactly where he trained is uncertain, but it is clear that the art of Giovanni Bellini made an impression on him early and continued to influenced him throughout his life. The two side panels of this triptych (depicting saints Sebastian and Mark) are now in the National Gallery, London. Judging from the meticulously rendered details – the bee, the movement of Gabriel's robe, the sheet of paper (on which Cima has written the names of the five people who commissionned this work), the landscape in perspective beyond the open shutters – it appears as if the artist has attemtped to bring the scene to life to the point of optical illusion.

(Right) Simplicity, clearly articulated compositions and an overall lack of dramatic effect could summarise Perugino's art. His portraits are direct, his characters always depicted in contemplative moods – such is the case with *St Sebastian*.

Sebastian was a Roman officer who, according to legend, was condemned to death as punishment for his Christian faith. The saint and martyr is usually represented full-length, bound to a pillar and pierced by nine arrows, but here Perugino has simply portrayed his head and his torso, eyes gazing upwards, and focused on the youth's handsome, regular features. A single fatal arrow piercing the saint's neck (and bearing the artist's signature in gold) is the only reminder of the dramatic subject.

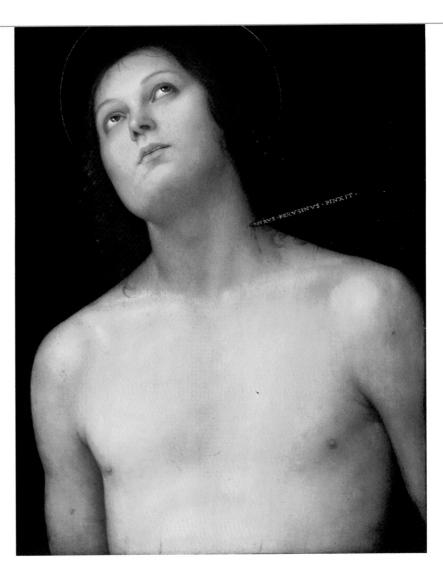

Perugino
(Pietro Vannucci)
*c.*1450–1523
Italy; Umbrian school
St Sebastian, *c.*1495
Tempera and oil on panel,
53.8 × 39.5 cm
From the Marchesa Campanari
collection, Rome, 1910;
formerly in the Princess
Volkonskaya collection

Raphael is remembered mostly for the frescoes that hang in the Vatican's Rooms and for his extremely moving paintings of madonnas. This *Madonna and Child* is a rare early work painted by the twenty-year-old artist for Alfano di Diamante. It already shows signs of what would become the hallmarks of Raphael's style: human warmth, serenity and superb draughtsmanship. His art epitomized the High Renaissance qualities of harmony and ideal beauty.

In the early eighteenth century, Diamante's heirs adopted the title of counts Conestabile della Staffa and this name was subsequently attached to the picture. When, in 1869 Count Conestabile decided to sell his art collection the Hermitage expressed an interest in the *Madonna and Child* on behalf of the Empress Maria Alexandrovna. The Italian public was indignant at the loss of such a masterpiece but the Italian government could not afford to purchase it so the painting was acquired by the Hermitage and arrived in St Petersburg in 1871. Upon its arrival it was transferred from panel to canvas: this is when it was discovered that the child had originally been holding a pomegranate in his hand, and not a book.

(Right) One of the greatest masters of the High Renaissance, Raphael's reputation was already excellent in his lifetime, and he was, according to the sixteenth-century art historian and biographer Giorgio Vasari, the 'prince of painters'. This painting of *The Holy Family* seems to have passed through many hands since its creation, and has seriously suffered from unskilled restoration; so much so that, at one point, there were doubts expressed as to whether or not it was a genuine Raphael. Since then, however, the authenticity of the attribution has been established beyond doubt. Indeed, the composition is highly characteristic of the master, in the manner in which he frees the figures from the level of everyday life and raises them to a plane of harmony and perfection. *The Holy Family* may have been painted for Guidobaldo da Montefeltro, Captain of the Florentines, during Raphael's sojourn in Florence, where he studied the art of Leonardo da Vinci.

Raphael (Raffaello Sanzio)
1483–1520
Italy; Roman school
The Holy Family (*Madonna with the Beardless Joseph*), c.1506
Tempera and oil on canvas (transferred from panel), 72.5 × 56.5 cm
From the Antoine Crozat, Baron de Thiers, collection, Paris, 1772

(Left)
Raphael (Raffaello Sanzio)
1483–1520
Italy; Roman school
Madonna and Child (*Conestabile Madonna*), c.1503
Tempera on canvas (transferred from panel), 17.5 × 18 cm
From the Count Conestabile della Staffa collection, Perugia, 1870

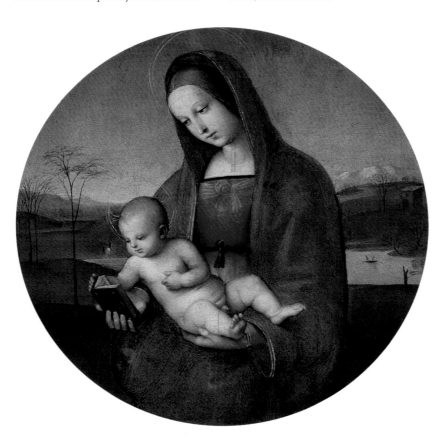

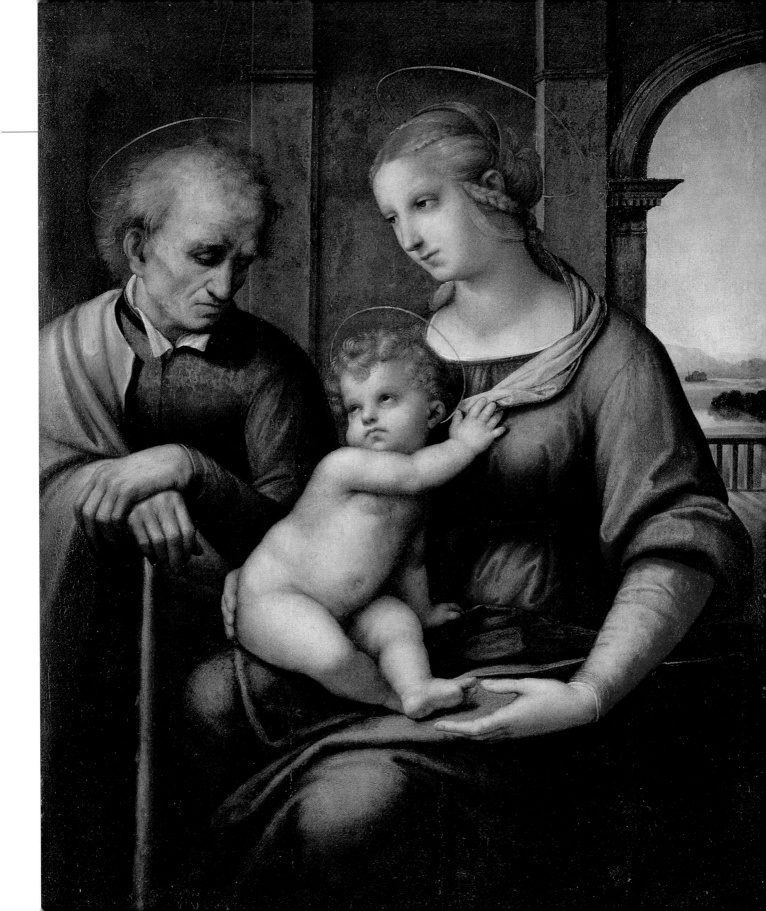

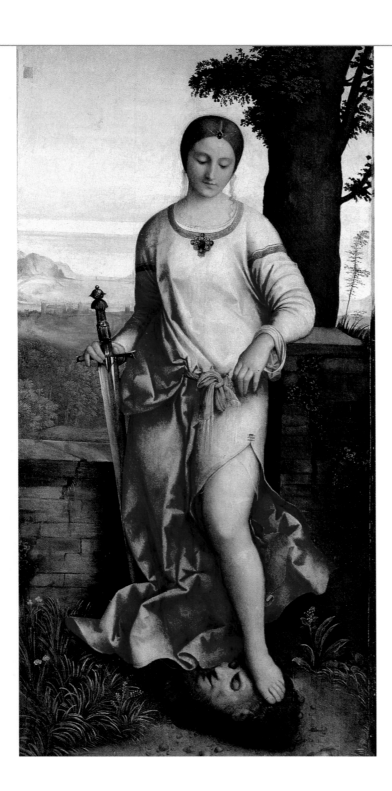

This painting of Judith is regarded as the greatest of the Hermitage's works from the Venetian school. According to the Bible, Judith was a powerful widow who saved her city and her people from the invading Assyrians by tricking the Assyrian commander, Holofernes, into thinking she was on his side. After a banquet where at which he tried to seduce her, she chopped off his head.

Judith is usually represented in the act of severing the head of Holofernes – the final dramatic scene of the legend. Contrary to the established iconographic tradition, here Giorgione shows her meditating on the significance of her deed. Her dress is cut seductively high, her bare leg is revealed, as is the weapon that led to the Assyrian's fall. The landscape and Judith's facial expression are serene, and nothing would betray the dramatic events that have just unfolded, were she not standing with her foot resting on the severed head of Holofernes – it is said that Giorgone used his own face as a model for the commander.

**Giorgione
(Giorgio da Castelfranco)**
c.1477–1510
Italy; Venetian school
Judith
Oil on canvas (transferred
from panel), 144 × 68 cm
From the Antoine Crozat,
Baron de Thiers, collection,
Paris, 1772

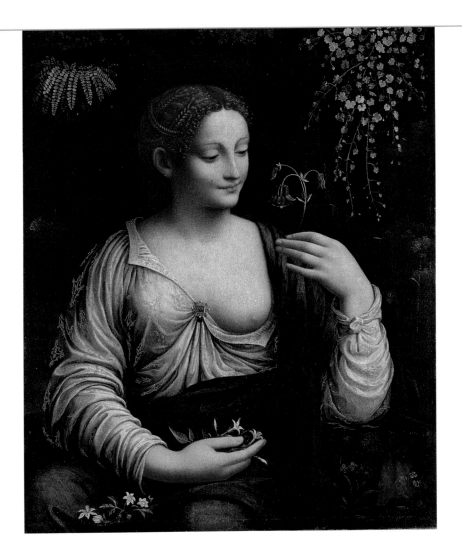

Francesco Melzi was a favourite pupil of Leonardo da Vinci, to whom, until the 1850s, this painting was attributed. Indeed, Melzi borrowed virtually all the details – the way the woman is sitting, the way she smiles and holds her hands, the style of her hair and dress, the use of plants and the use of sfumato and chiaroscuro – from the works of his great teacher.

For a long time this work was entitled *Columbine*, after the flowers in the woman's right hand. Some scholars believed that it represented Babon de la Bourdecier, one of the noble ladies at the French court of François I. Others made an equally justifiable assumption that it portrayed Mona Lisa as Flora. A study of the flowers depicted: aquilegia – symbol of fertility, jasmin – symbol of lost chastity, and fern – symbol of solitude and dreaminess, has led modern researchers to definitively attribute the work as one of Melzi's and name its subject as Flora, the goddess of flowers in classical mythology.

Francesco Melzi
1493–1570
Italy; Milanese school
Flora, c.1520
Oil on canvas (transferred
from panel), 76 × 63 cm
From the sale of the
William II collection,
The Hague, 1850

Lorenzo Lotto drew inspiration from Titian and Raphael
but also from northern painters – especially Dürer, who
had been in Venice at the turn of the century. At his best in
portrait painting, Lotto was fond of interweaving realistic
details with allegorical symbols and metaphors. In this picture,
for example, the dog in the arms of the lady implies fidelity
while the squirrel curled up on the table alludes to a
contemporary popular legend telling how the cruel male
squirrel used to drive its female companion out of the nest
in lean winters. The sheet of paper held by the man bears
a Latin inscription, *Homo nunquam* ('Man Never'). Note the
table itself, a strong focal point of the painting, with its
elaborately patterned cloth – such tables occur frequently in
Lotto's portraits. The couple's love and devotion to each other
is echoed by the landscape outside the window, in which two
trees are bowed down by a furious wind, but hold together
firmly against the turbulent elements.

Lorenzo Lotto
1480–1556
Italy; Venetian school
Family Portrait, c.1523
Oil on canvas, 96 × 116 cm
Acquired between 1773 and 1785;
formerly in the Jan and Jakob
van Buren collection, Antwerp

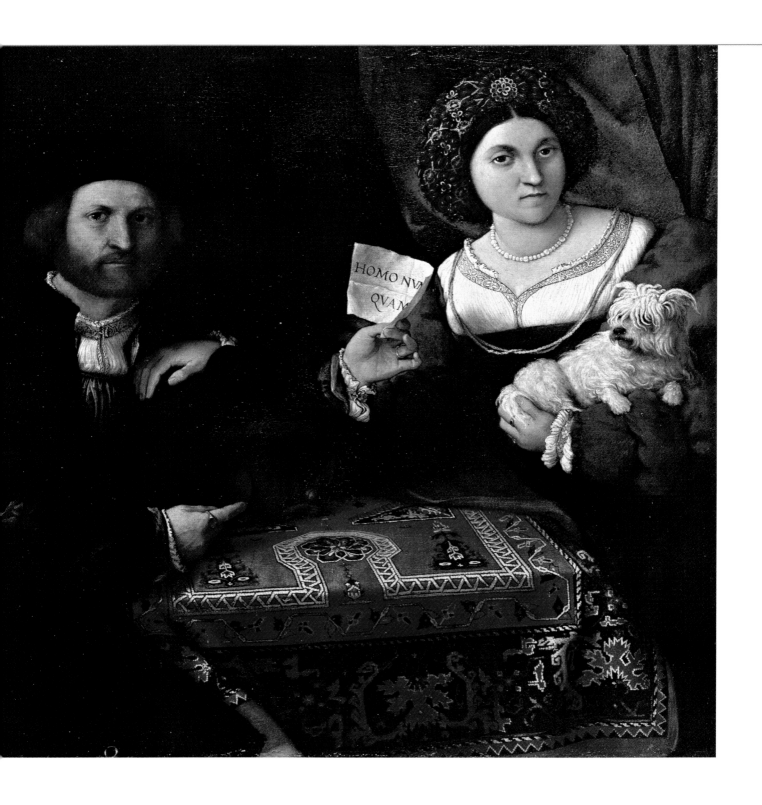

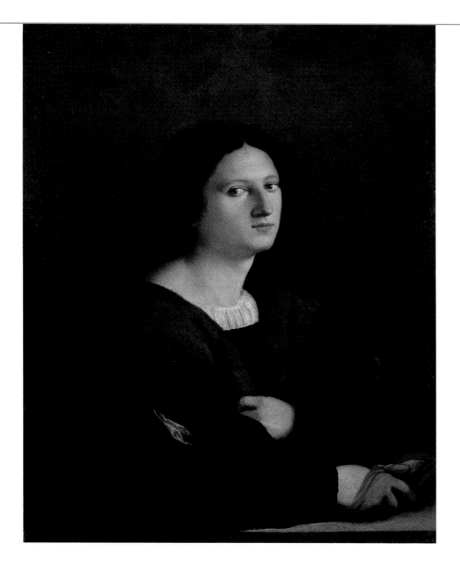

(Left) Palma Vecchio's portraits were immensely popular in his lifetime and he was highly instrumental in the way in which Venetian portraiture developed. The noble origin of the man portrayed here is implied by such details as the robe and the gloves, which, in those days, along with swords, symbolized authority and high social standing. It is also corroborated by the colour scheme: at first glance almost monochromatic, a closer examination reveals a rich and subtle variety of greys and browns. Palma's *Portrait of a Young Man* was undoubtedly influenced by Giorgione, another Venetian painter and a contemporary of Palma – the three-quarter profile and the way the body leans slightly forward are both characteristics of Giorgione's style.

(Right) *The Holy Family with St Catherine* was attributed to Leonardo da Vinci until the end of the nineteenth century. The famous French writer and critic Stendhal even considered it to be the best work the master ever painted. However, it is, in fact, a splendid example of the talent of Leonardo's pupil, Cesare da Sesto. The figures are given a convincing plasticity and weight; the colouring is noble and restrained. Note also the discreet inner pride with which the majestic Mary shows her curvy, merry child (and how wonderfully natural his movements and facial expression are). It is clear that the artist used the same model for both of the female figures in the picture.

Palma Vecchio (Jacopo Palma)
1480–1528
Italy; Venetian school
Portrait of a Young Man, 1510s
Oil on canvas, 93 × 72 cm
From the Golitsyn Museum,
Moscow, 1886

Cesare da Sesto
1477–1523
Italy; Milanese school
*The Holy Family with
St Catherine*, 1515–20
Oil on canvas (transferred
from panel), 89 × 71 cm
Acquired between 1753
and 1774

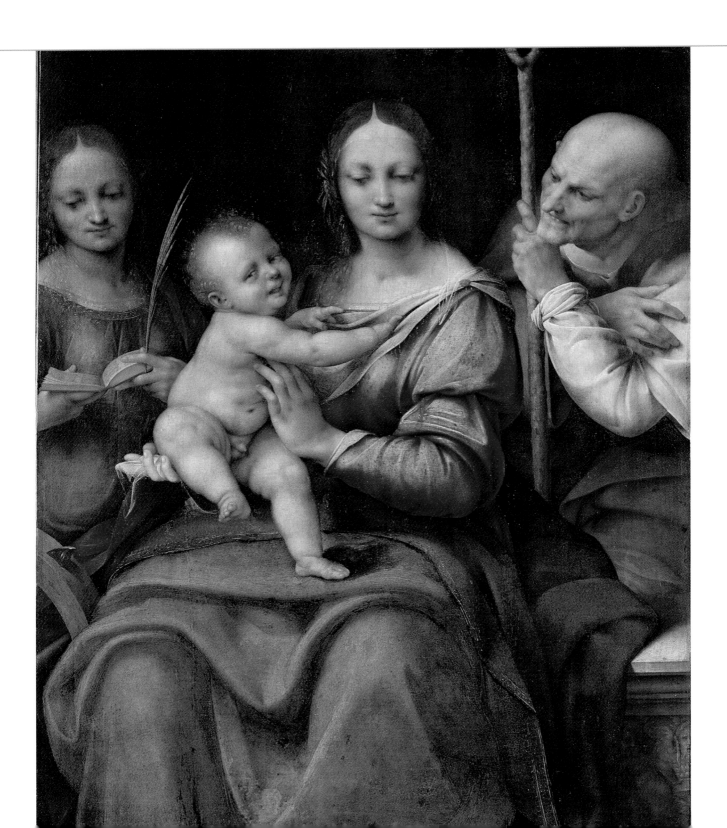

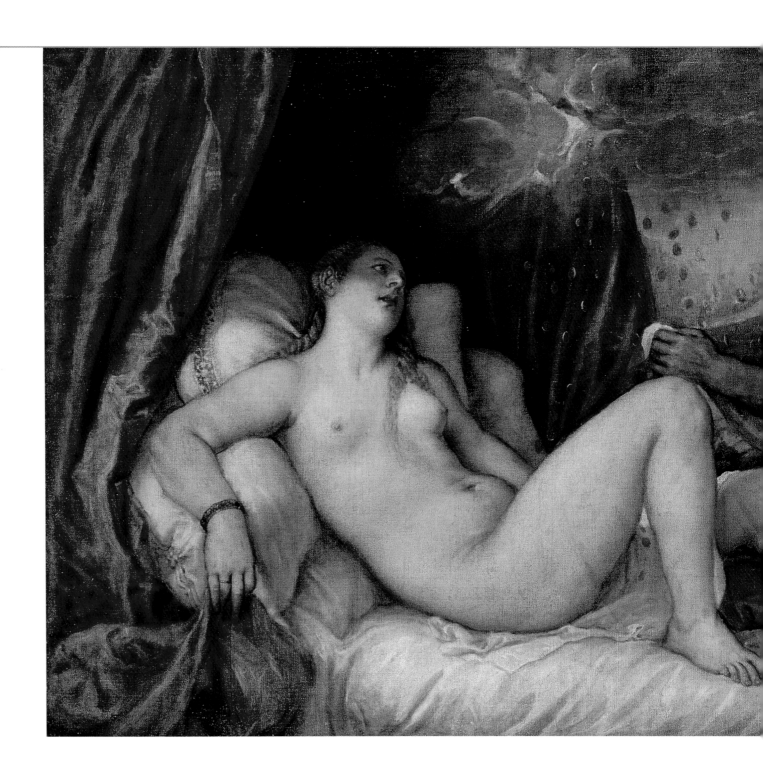

Trained under Giovanni Bellini and Giorgione, Titian became the greatest of the sixteenth-century Venetian artists, remarkable for his extraordinary use of colour. This painting is one of a series of mythological paintings, or 'poesie', executed for one of Titian's illustrious patrons, Philip II.

In Greek mythology, Danaë was the daughter of the King of Argos and the mother of Perseus. It was prophesied that she would bear a son who would kill the king, so, to protect himself, the king shut her up in a bronze tower. However, Jupiter, charmed by her beauty, visited her in the guise of a golden shower, made love to her, and Perseus was the result.

This a work from Titian's mature period, in which there is a close harmony between form and content. The artist has endowed the mythological heroine with the features of contemporary Venetian ladies. Her graceful pale, nude, body contrasts with that of the ageing servant, her voluptuousness with her maid's greediness. Titian's palette is powerful and sumptuous. Combining warm brown, golden and pink colours with cool grey and blue tones, he manages to create an atmosphere of intimate warmth and sexuality.

The enormous success of this picture prompted the artist to make several copies of it. The best replicas are now in the Prado Museum in Madrid, the Capodimonte Museum in Naples and the Kunsthistorisches Museum in Vienna.

Titian (Tiziano Vecellio)
c.1488–1576
Italy; Venetian school
*Danaë, c.*1554
Oil on canvas, 120 × 187 cm
From the Antoine Crozat,
Baron de Thiers, collection,
Paris, 1772

Titian, Tiziano Vecellio
(*c*.1488–1576)
Italy; Venetian school
St Sebastian, 1570s
Oil on canvas,
210 × 115.5 cm
From the Barbarigo Palace,
Venice, 1850

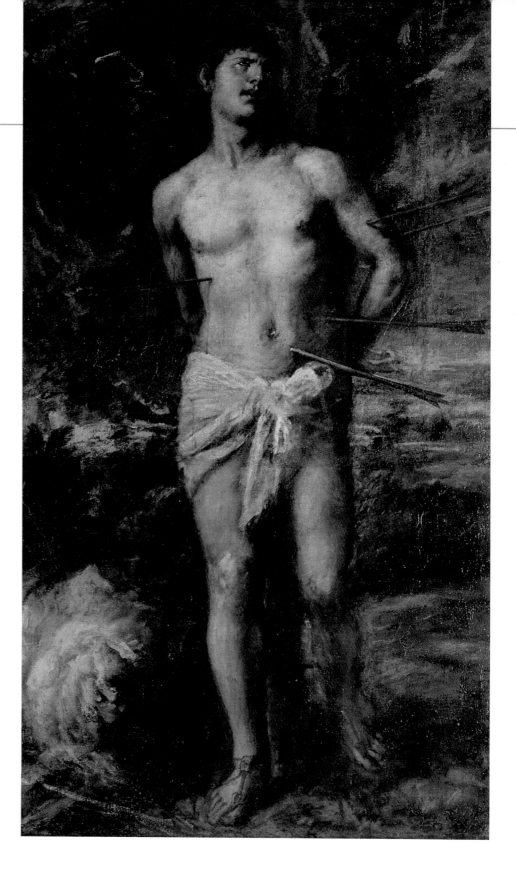

(Left) The Hermitage is proud of its eight paintings by Titian, the most important of which, *St Sebastian*, dates from the artist's late period. It is one of the last works by the great master and one of the most tragic images of Italian Renaissance art. Man's resistance to hostile forces, the principal theme of that period, acquires here truly heroic resonance.

This work was originally regarded by Titian as a sketch. He produced a half-length composition, but subsequently made additions to the right-hand and lower sections of the canvas – which may explain the somewhat unfinished look of these parts. The full-length figure does, however, create a more dramatic work.

(Right) This is another one of Titian's masterpieces, and no doubt the artist thought highly of it too, as the canvas remained in his household until his death.

According to the New Testament, Mary Magdalene was a rich and vain courtesan, a sinner who subsequently had seven devils cast out of her. She is then mentionned among the women who accompanied Christ and ministered to Him; she stood at the foot of the cross, saw Christ laid in the tomb, and was the first recorded witness of the Resurrection. The depiction of Mary Magdalene as a penitent, living in retreat in the desert once Christ had exorcised her the devils, does no appear in the Bible. It was only in the twelfth century that the legent arose of how she withdrew into a cave in order to do penance after a life of sin. She is usually shown as a beautiful Venetian woman, with striking long hair and a jar of ointment. Here, the inflamed reddened eyelids, the face slightly swollen from weeping and the eyes raised towards a vision of angels in heaven,all express the deep penitence and grief of the sinner.

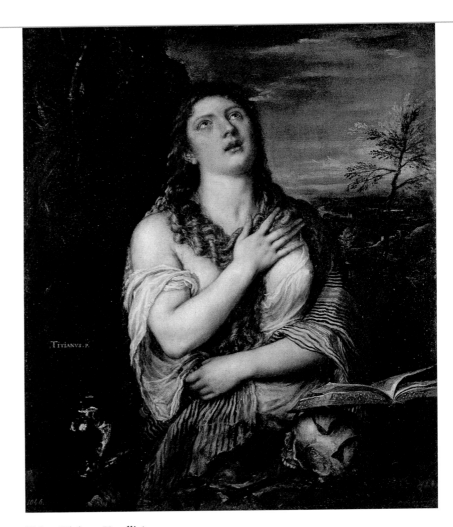

Titian (Tiziano Vecellio)
*c.*1488–1576
Italy; Venetian school
The Penitent Mary Magdalene, 1560s
Oil on canvas, 118 × 97 cm
From the Barbarigo Palace, Venice, 1850

Il Tintoretto was the last great master of the Italian Renaissance and this is the only painting by him in the Hermitage. He mostly worked for the Venetian *scuole* in return for his keep and to see his oeuvre properly one should visit Venice, and the Scuola di San Rocco in particular, where many of his works are kept.

This picture was formerly known as the *Birth of Mary*, but it is clear that it actually shows the birth of St John the Baptist, with, in the background, John's father, the High Priest Zacharias, as he regains the gift of speech. In the Gospel According to St Luke (1:7–22) God punishes the ageing priest Zacharias for refusing to believe that his elderly wife will bear him a son. Zacharias is struck dumb until the birth of his child, John.

Il Tintoretto
(Jacopo Robusti)
1518–94
Italy; Venetian school
Birth of St John the Baptist, 1554–55
Oil on canvas, 181 × 266 cm
From the Antoine Crozat,
Baron de Thiers, collection,
Paris, 1772; formerly in the
Cardinal Mazarin collection

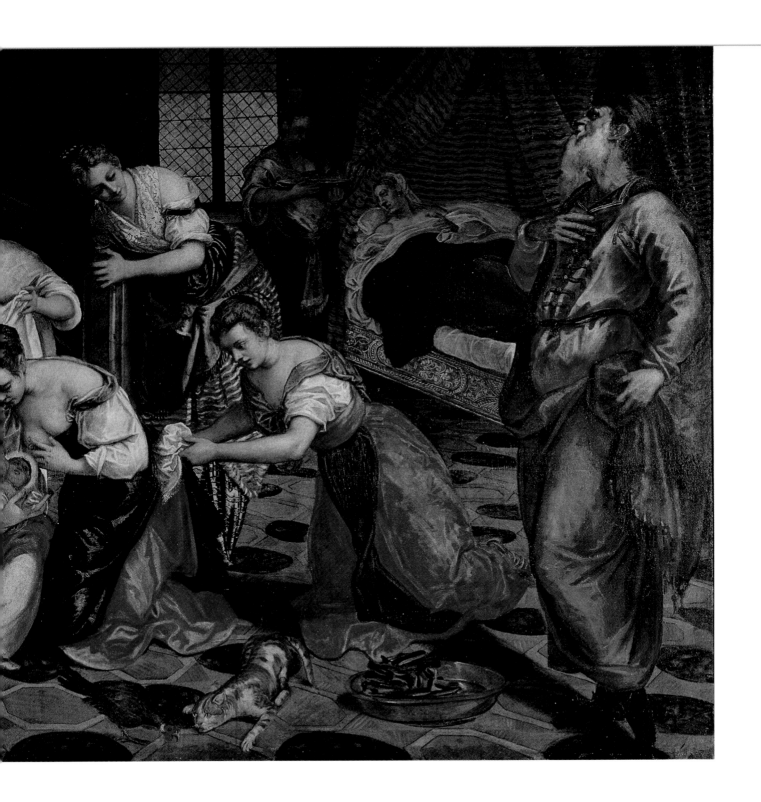

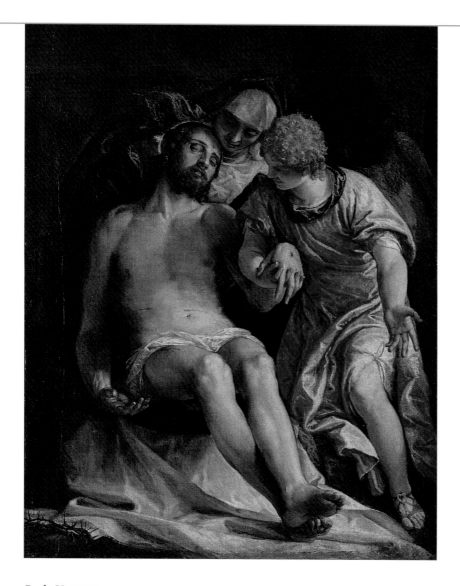

(Left) This painting by Veronese, another major Venetian artist, was mounted on the altar of the Church of Santi Giovanni e Paolo in Venice in 1582. Its immensely expressive but restrained composition makes it stand out from Veronese's other grandiose works on the same subject. However, even here his brilliance in using colour is striking. The dead body of Christ has been taken down from the Cross: his head seems to rest on Mary's shoulder and the Angel holds his hand. The scene's dramatic effect is heightened by Veronese's use of contrasting warm and cold colours tones.

X-rays have revealed that a second angel once supported Christ on the left, but for some reason the figure was painted over.

(Right) There were three important members in this Bolognese family: Lodovico Carracci, and his cousins Agostino and Annibale Carracci, who were brothers. The trio were brilliant artists, but it is Annibale, a pupil of Lodovico, who was by far the most talented.

The subject of this painting is taken from the Gospel According to Matthew (28:1–17). Three days after the deah of Christ, the three Marys (including Mary Magdalene) come to Christ's tomb to anoint His body, but discover that it has gone. Instead they meet the Archangel Gabriel, who shows them the empty tomb, announces that Christ has risen and instructs them to tell all the disciples.

Paolo Veronese
(Paolo Caliari)
1528–88
Italy; Venetian school
Pietà, between 1576 and 1582
Oil on canvas, 147 × 111.5 cm
From the Antoine Crozat,
Baron de Thiers, collection,
Paris, 1772; formerly in the
Charles I collection

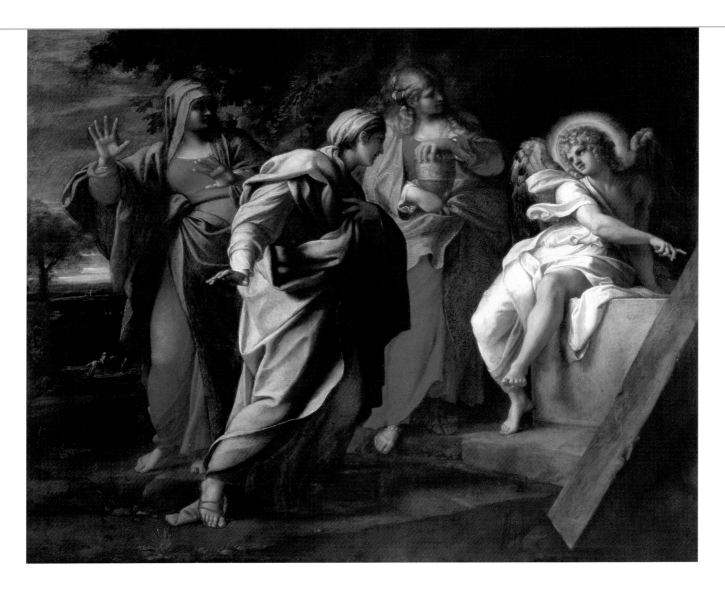

Annibale Carracci
1560–1609
Italy; Bolognese school
*The Holy Women at Christ's
Tomb*, 1597–98
Oil on canvas, 121 × 145.5 cm
From the William G. Coesvelt
collection, London, 1836

This is an early work by Caravaggio, but we can already see the elements of the artist's style that were to have such a widespread influence on other artists – the modelling of the flesh, for example, the use of lighting on the boy's skin and shirt, and the sharp sidelighting and falling shadows that give the objects an almost tangible volume and weight.

By 1595 Caravaggio had been in Rome for at least a few years and was working for a group of patrons in the circle of Cardinal Francesco del Monte. The works produced at this time included several paintings of young boys, loosely draped in fabric and usually half-length, which almost certainly have erotic overtones. The subject of *The Lute Player* has given rise to many interpretations, but the most appropriate, perhaps, is as an allegory of Love. It is expressed in a complex set of symbols, characteristic of the lyric poetry of the late sixteenth century. The melody written on the pages of the open score is that of a then fashionable love song, by the sixteenth-century composer Jacques Arcadelt.

Caravaggio
(Michelangelo
Merisi da Caravaggio)
1571–1610
Italy; Roman school
The Lute Player, c.1595
Oil on canvas, 94 × 119 cm
From the Giustiniani
collection, Paris, 1808

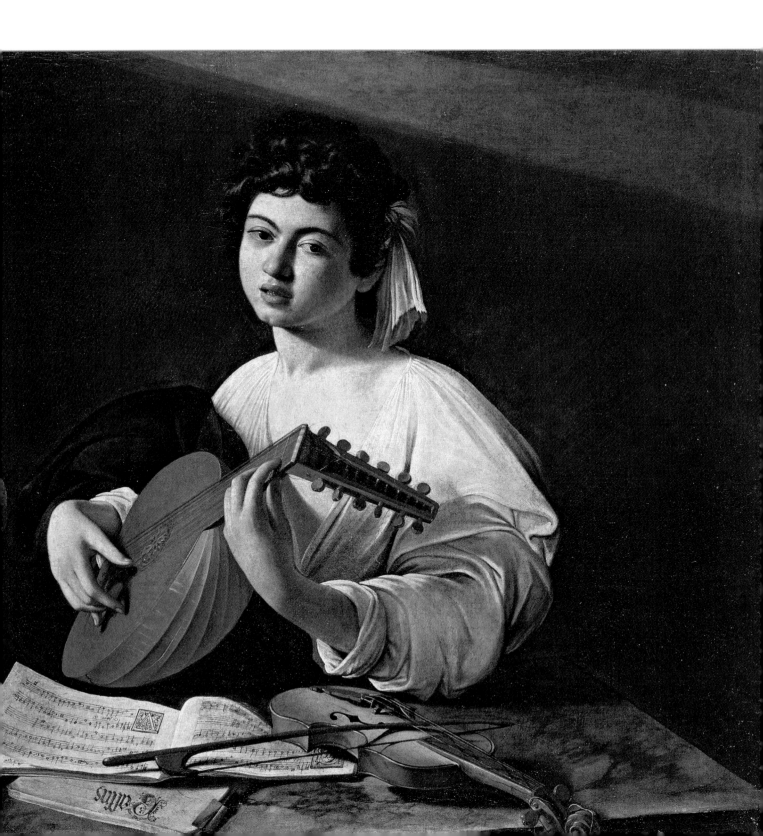

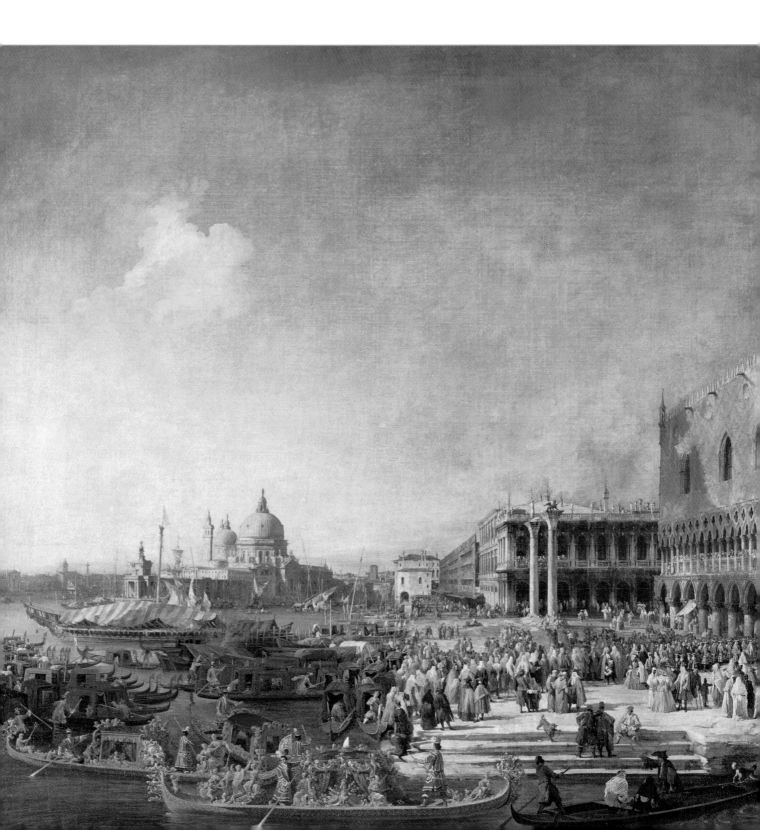

Canaletto's work was so fashionable in the eighteenth century that no English tourist on the Grand Tour would go back to England without having first bought one of his paintings as a souvenir.

The *Reception of the French Ambassador in Venice* describes the triumphant meeting between the French Ambassador and the Doge of Venice on the 16th of May 1725, a date borne out by the correspondence between Canaletto's patron, Stefano Conti, and the artist Alessandro Marchesini. While the picture accurately records the historical details of the event, it is also a romantic perception of what took place. It displays Canaletto's masterly use of perspective, his crisp depiction of the architectural buildings of Venice, his ability to impart a real atmosphere of festivity and his clever use of light – all the qualities that set his work apart from that of his contemporaries, and make him the greatest Venetian *vedutista* (view painter) and the most instantly recognisable.

Canaletto (Antonio Canal)
1697–1768
Italy; Venetian school
*Reception of the French
Ambassador in Venice*, 1725–26
Oil on canvas, 181 × 259.5 cm
Acquired between 1766 and 1768

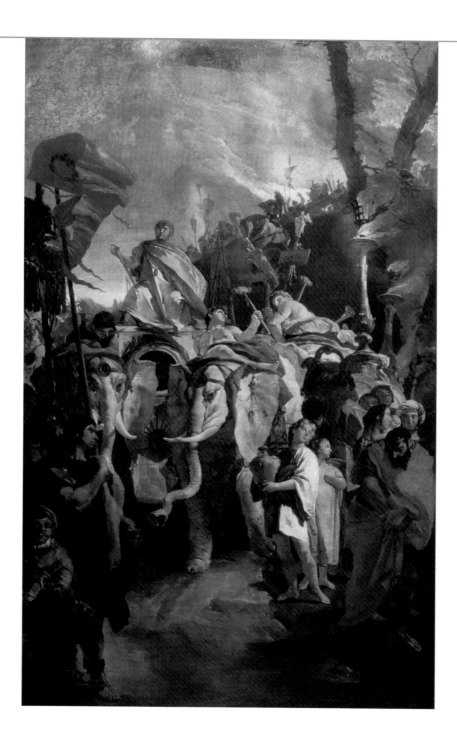

Tiepolo was commissioned to complete
ten canvases on themes from the early
history of the Roman Empire to adorn the
walls of the Palazzo Dolfin in Venice. Two
of these canvases are in the Kunsthistorisches
Museum in Vienna, three in the Metropolitan
Museum in New York, and five in the
Hermitage.

This picture, which shows the triumph of
the Roman General Manius Curius Dentatus,
over Pyrrhus in 275BC, is the largest of them
all. An undisputed master of fresco painting,
Tiepolo developed the composition from the
luminous background to the vivid foreground
with an acute sense of perspective. The
colourful, powerful procession seems to be
moving directly towards the onlooker and
out beyond the picture frame.

Giovanni Battista Tiepolo
1696–1770
Italy; Venetian school
*The Triumph of the Commander
Manius Curius Dentatus*, 1725–30
Oil on canvas, 550 × 322 cm
From the Museum of the
Baron Stieglitz School of
Industrial Design, St Petersburg,
1934; acquired by Alexander
Polovtsov for the museum
in the Palazzo Dolfin, Venice

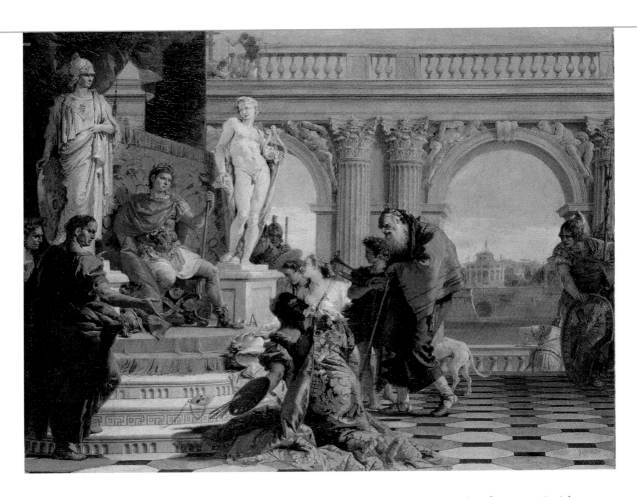

Giovanni Battista Tiepolo
1696–1770
Italy; Venetian school
*Maecenas Presenting the
Liberal Arts to the Roman
Emperor Augustus*, 1743
Oil on canvas,
69.5 × 89 cm
From the Heinrich Brühl
collection, Dresden, 1769

This picture was intended to glorify the life and works of Count Heinrich von Brühl (1700–64), a well-known connoisseur and collector of paintings, for whom it was intended. Brühl's position at the court of Augustus III, Elector of Saxony and King of Poland, was similar to that which the Roman Maecenas, a statesman and patron of the arts, held under the Emperor Augustus. The allegorical figures personifying Painting, Sculpture and Architecture appear before the Roman emperor in the company of the blind Homer, personifying Poetry. The count's Dresden palace is depicted in the foreground of the picture, seen through the arch of an 'antique' building.

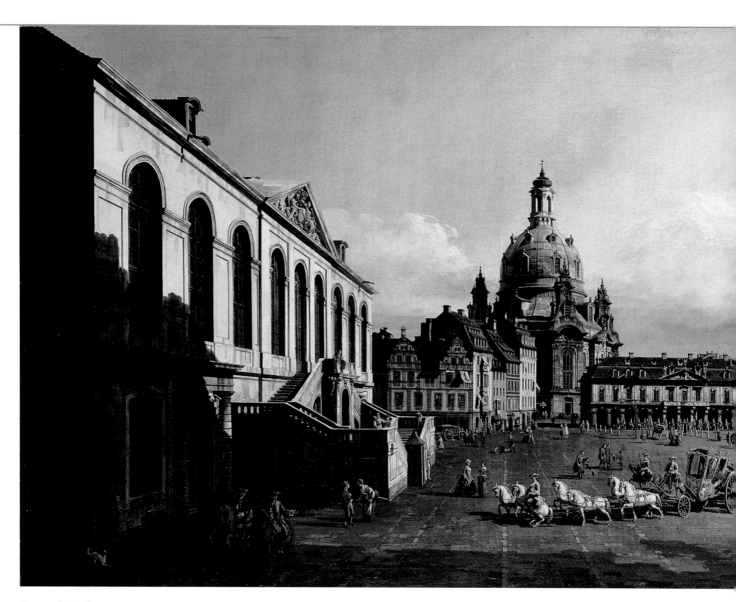

Bernardo Bellotto
1720–80
Italy; Venetian school
Neuer Marktplatz in Dresden
(The New Marketplace
in Dresden), 1747
Oil on canvas, 134.5 × 236.5 cm
From the Heinrich von Brühl
collection, Dresden, 1769

(Left) Bernardo Bellotto was the nephew and pupil of Canaletto, and often 'borrowed' his uncle's nickname to sign his own paintings. In 1747 he was summonned to Dresden and left Italy, never to return. He became Court Painter to Augustus III, King of Poland and Elector of Saxony, in 1748, and over the following eight years painted many views of Dresden, capital of Saxony, and of Pirna, a small town to the south, for the king. He painted a second series of Dresden views to express his gratitude to his patron, Count Heinrich von Brühl, who had helped him secure the king's commission. That series was acquired in 1769, with the rest of Brühl's collection, by the Russian Empress Catherine II.

Of the ten 'Brühls' that belong to the Hermitage, this is the earliest. The building to the left was then Dresden's picture gallery, the Gemäldegalerie; in the background is the Frauenkirche; in front of the church are the royal stables, later destroyed by Prussian troops in 1760. There is much resemblance to Canaletto's style: the faultless typographical drawing and the attention to detail, for example – so accurate are Bellotto's views of Dresden that they were used to help rebuild the city after its near-total destruction during World War II.

(Below) In his small atmospheric townscapes, Francesco Guardi recorded the romantic image of Venice. He was a prolific painter and his work much collected in the eighteenth century, but his paintings only sold for half the price of those by Canaletto, for whom he had worked in the 1770s.

View of a Square is a *capriccio*, – a landscape mixing real and imaginary buildings, rather than a topographically accurate depiction of a spot in the city. Here Guardi achieves a most picturesque effect by depicting the view through an archway (a characteristic of his work), with dark shadowy tones in the foreground, leading to contrasted brighter, sunnier colours in the background.

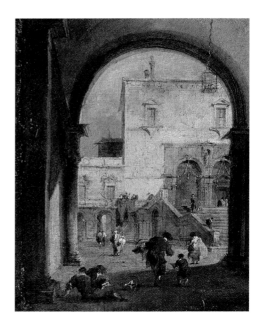

Francesco Guardi
1712–93
Italy; Venetian school
View of a Square with a Palace, 1775–80
Oil on canvas (transferred from panel), 27 × 23 cm
From the V. Kostromitinova collection, St Petersburg, 1895

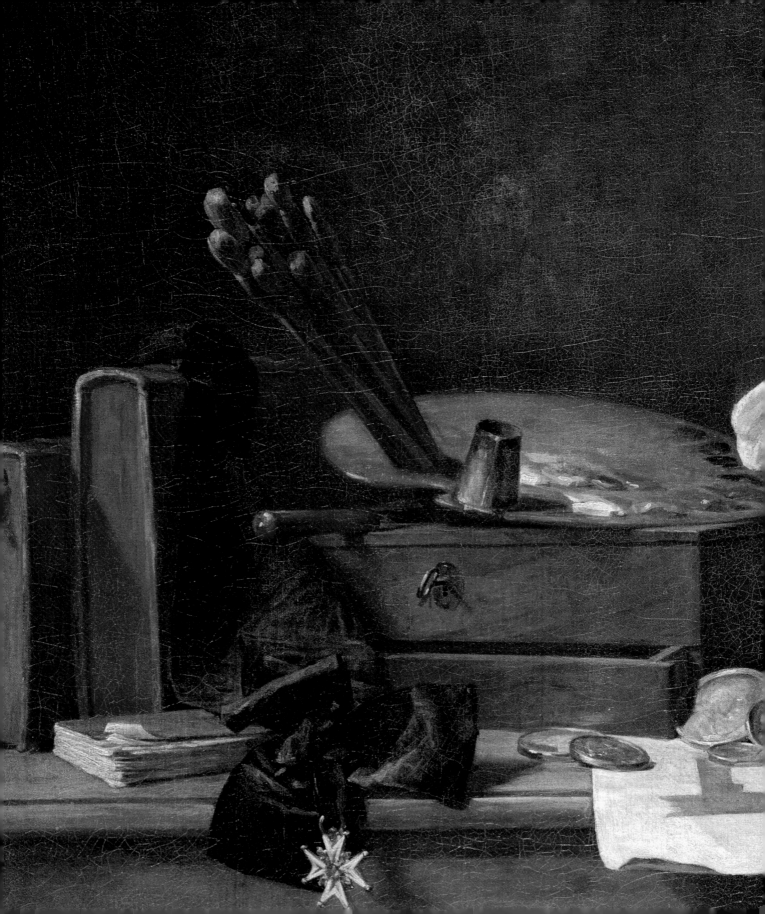

FRENCH PAINTING

**Jean-Baptiste Siméon
Chardin**
1699–1779
*Still Life with the Attributes
of the Arts*, 1766 (detail)

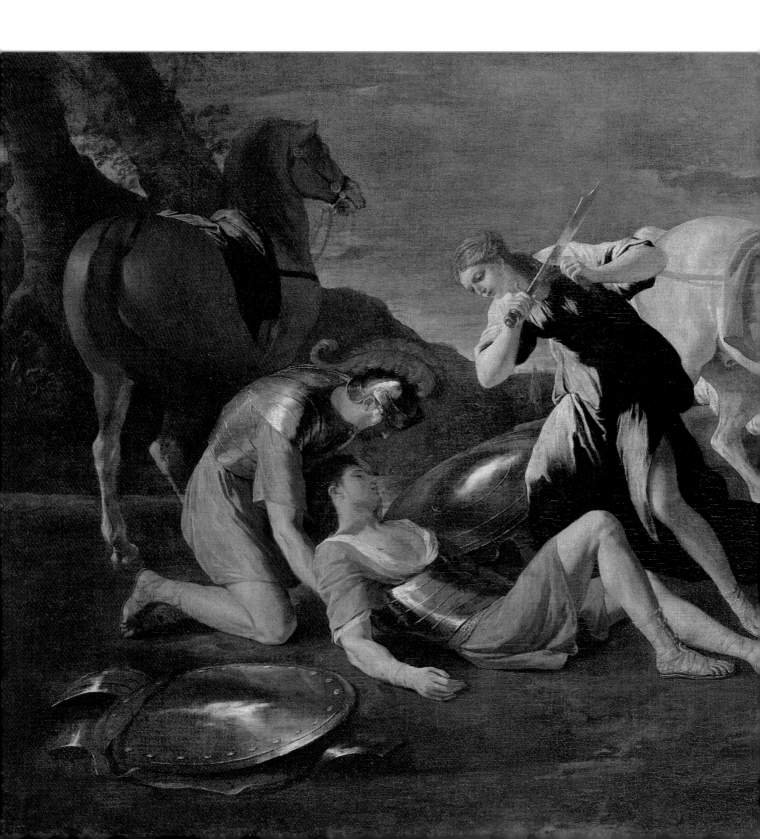

Nicolas Poussin was the leading exponent of French classical painting. The successes of France against the Habsburgs in the Thirty Years' War (1618–48) deeply influenced the mood of French society in the mid-seventeenth century. In search of lofty ideals, French artists turned to classical history. Poussin's work, noble in spirit and exalted in feeling, embodied the ideals of reason, order, harmony and justice.

In this masterpiece, based on a subject from the Italian poet Torquato Tasso's *Jerusalem Delivered* (1581), the sorceress Erminia, whose spells have mortally wounded the Crusader knight Tancred, suddenly realises her true feelings towards him and is shown sacrificing her magic hair to heal the dying man's wounds. The sense of human drama is highlighted by the contrast between the stillness of Tancred and the sharp movement of Erminia, whose body is lit in a way that stresses her resolve and desparation.

Nicolas Poussin
1594–1665
France
Tancred and Erminia, c.1630
Oil on canvas, 98 × 147 cm
From the J. A. Aved collection,
Paris, 1766

Drawing his inpiration from Ovid's *Metamorphosis*, Poussin has created a 'heroic' landscape, and painted an idealised image of Nature. Polyphemus is a one-eyed monster who loves a beautiful sea nymph named Galatea, who is herself in love with a Sicilian shepherd named Alcis. The cyclops, whose figure seems to rise out of a fissure in the mountain, is looking out to the sea into which Galatea has just disappeared with her lover. The unruly side of Nature that is usually personified is seen here tamed and transformed as he is expresses his love by playing a reed pipe, while behind him the valley falls under the spell of his music and the river and woodland gods stand still in wonder.

Nicolas Poussin
1594–1665
France
Landscape with Polyphemus, 1649
Oil on canvas, 149 × 197.5 cm
From the Marquis de Conflans
collection, Paris, 1772

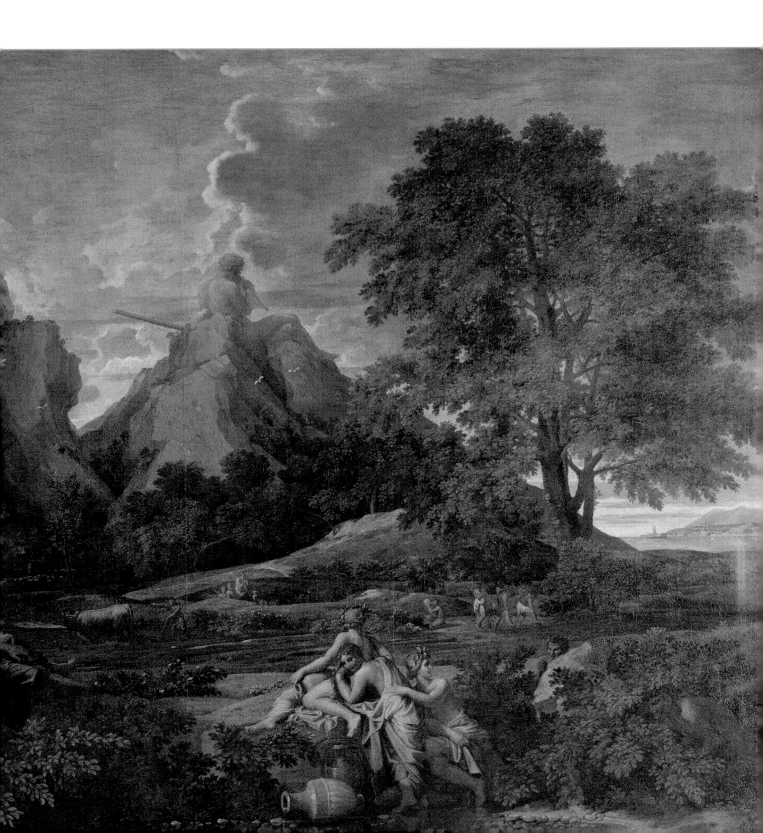

The *Milkmaid's Family* dates from Le Nain's peak period when his specific 'peasant' genre – which had no previous tradition in seventeenth-century France – took final form. Le Nain gives these simple people standing still and attentive around a little donkey – the family's breadwinner – an austere and dignified nobility. The low vantage point and the spreading flat landscape give further grandeur to the figures. If the work seems modest at first glance, a closer look reveals the variety of cool silvery-grey tones, confirming Louis Le Nain as an outstanding master of light and colour.

Louis Le Nain
1593–1648
France
The Milkmaid's Family, c.1641
Oil on canvas, 51 × 59 cm
Acquired between 1774
and 1783

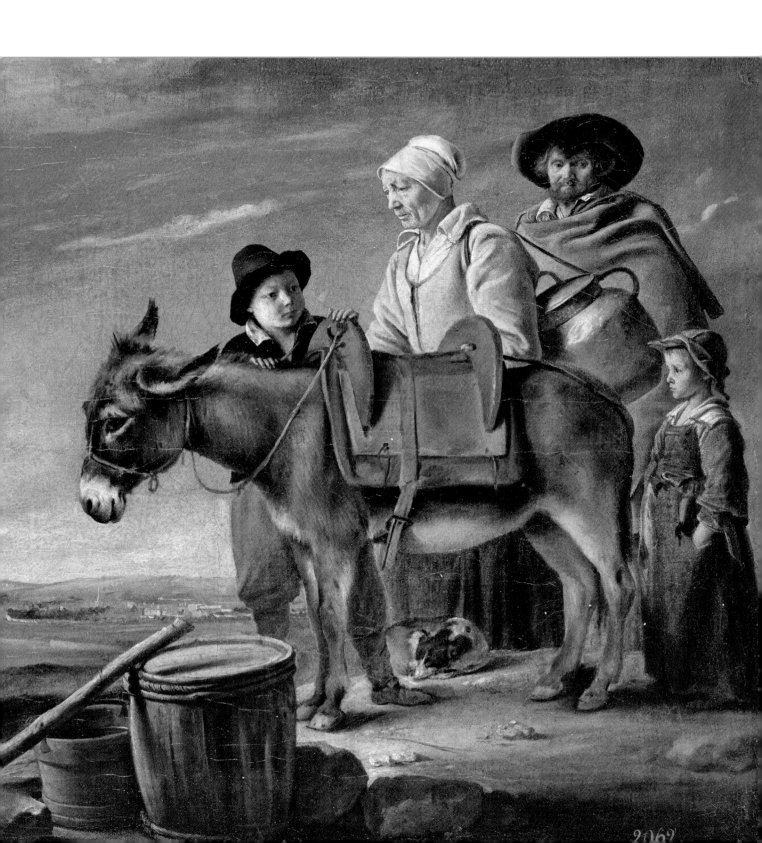

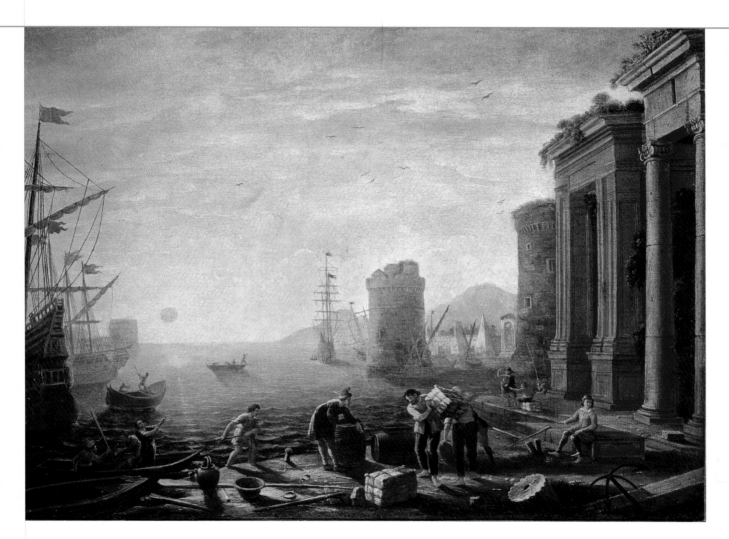

Little is known of Claude Gellée's first twenty-five years, except that he went to Rome as a youth in 1612, then spent the next fifteen years travelling before returning to Rome in 1627, where he spent the rest of his life. Almost all of his landscapes – often seaports and harbours – are devoted to Italy.

 Morning in a Harbour is built according to the classical canons, with 'wings' leading into the central space, where the depth of the picture is built up through the use of successive planes, and, of course, classical buildings set into the landscape. But Claude introduces an element that brings all these details to life: light. To create poetic lighting effects he does not use strong chiaroscuro like his predecessors, but paints the rising sun itself, a haze of golden light, its rays shimmering on the water and gilding the port workers as they go about their tasks. However, the heat is never oppressive in Claude's paintings, and in *Morning in a Harbour*, too, a refreshing breeze is seen unfurling the flags on the boats' masts.

**Claude Gellée
(Claude Lorraine)**
1600–82
France
Morning in a Harbour,
late 1630s
Oil on canvas, 74 × 97 cm
From the Baudouin collection,
Paris, 1781

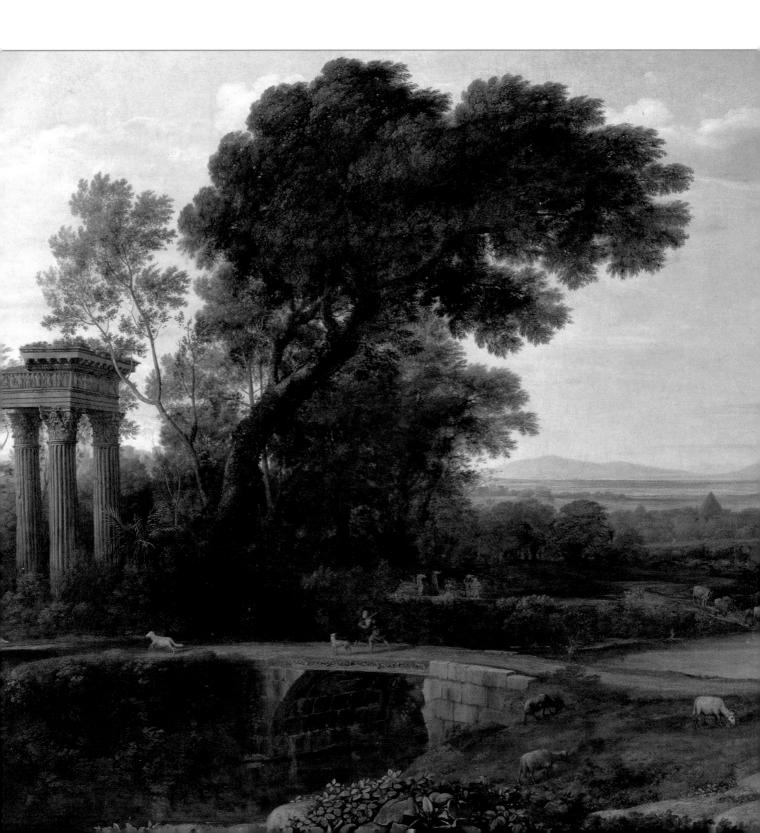

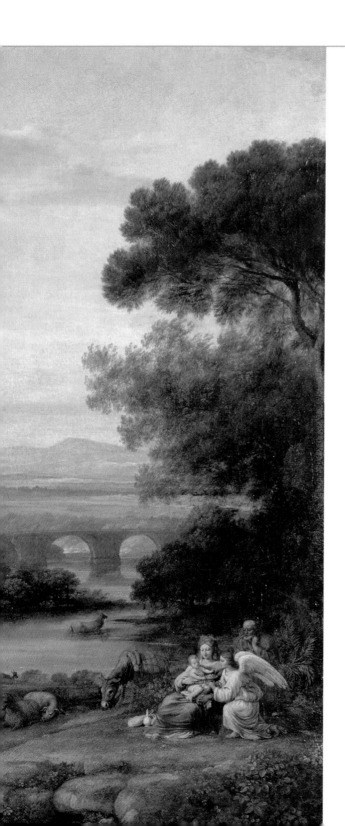

Claude Gellée was born in Lorraine, hence his other name, Le Lorrain, and sometimes, Claude Lorraine. A follower and admirer of Poussin, he is the originator of the pastoral, or picturesque, landscape and is renowned for his magical use of light – a reputation he already enjoyed during his lifetime.

The *Rest on the Flight into Egypt* is part of the *Four Times of Day* cycle housed in the Hermitage. It is a harmonious, calm and luminous tableau: the rays of the sun filter through the trees to fall on Mary's blue dress, highlighting the small human figures while at the same time absorbing them and the drama of their circumstances into the vast, sheltering, Nature.

Claude Gellée
(Claude Lorraine)
1600–82
France
Rest on the Flight into Egypt (Noon), between 1651 and 1661
Oil on canvas, 113 × 157 cm
From the Empress Josephine collection, Malmaison, 1814

Antoine Watteau
1684–1721
France
The Capricious Girl
(*La Boudeuse*), *c.*1718
Oil on canvas, 42 × 34 cm
From the Stroganov Palace
Museum, St Petersburg,
1923; formerly in the
Horace Walpole collection,
Strawberry Hill, England,
1779

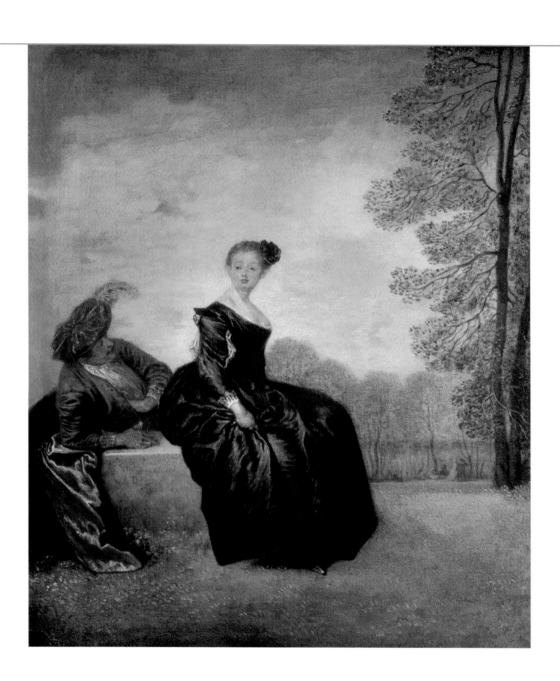

(Left) When Watteau was elected a member of the French Academy of Arts, a term was specially invented to describe the kind of painting for which he is now so well known and of which this work is an excellent example – the *fête galante*, a dream world of perfectly mannered human love and harmony with nature.

Flirting coquettishly yet innocently, the artist's imaginary heroes – the deliberately indifferent lady and her insistently attentive cavalier – are shown with gentle mockery, and the result is a warm and charming painting. The canvas dates from Watteau's late period and is painted in a seemingly fresh and unassuming style, but with great skill, and glowing with complex nuances of colour and reflections of light.

(Right) This is one of Watteau's most famous paintings, dating from his mature period, in which he depicts an itinerant musician from the mountains of Savoy, probably basing the painting on drawings made from life. In the eighteenth century, Savoie was France's poorest province and its inhabitants often had to leave home to seek work in large towns elsewhere. In this fresh, unassuming composition that is typical of Watteau, the Savoyard stands in the sunlit square of a small town, tenderly smiling at the spectator.

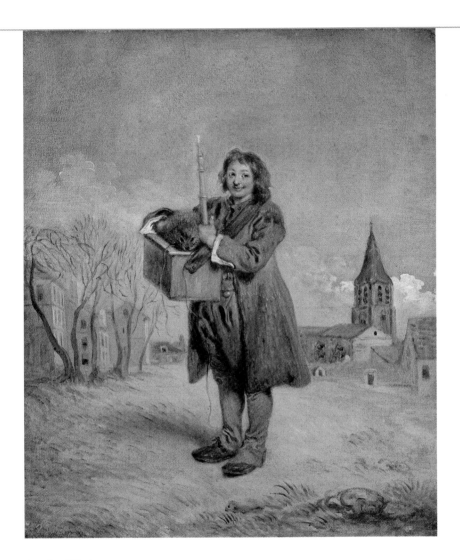

Antoine Watteau
1684–1721
France
Savoyard with a Marmot,
c.1716
Oil on canvas, 40.5 × 32.5 cm
Acquired in 1774;
formerly in the Audran
collection, Paris, until 1734

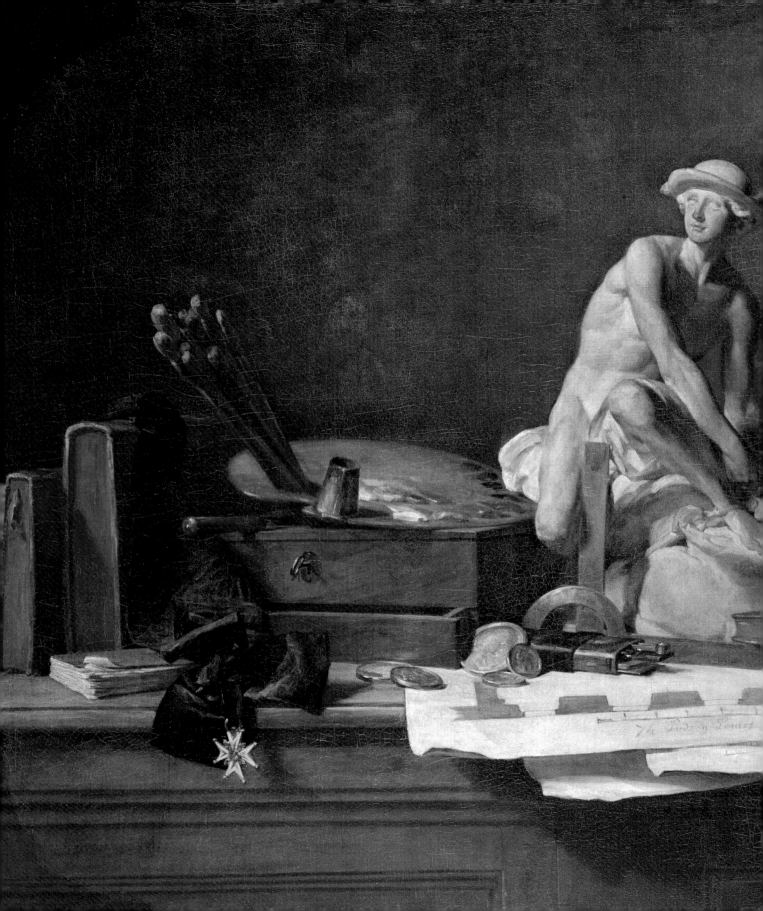

In 1763 French critic and writer Diderot wrote that a still life by Chardin "is nature itself; the objects free themselves from the canvas and are deceptively true to life". Commissioned by Catherine II for the Conference Hall of the Academy of Arts, this painting was completed and brought to Russia in 1766. It is regarded as one of Chardin's best allegorical still-lifes and glorifies art and the artists. At its centre, representing sculpture, is the statuette of Mercury, patron of the arts, by Jean-Baptiste Pigalle, while around it are the attributes of the other arts: the palette and brushes symbolising painting, the architectural plans and surveying tools symbolising architecture, the red portfolio signifying drawing, the bronze pitcher signifying goldsmithing... The cross on a ribbon is the Order of Saint Michael, the highest honour an artist could then receive – an honour Pigalle was the first sculptor to win.

It is generally accepted that the painting was brought to St Petersburg by the sculptor Falconet, who had been invited there to work on the equestrian statue of Peter I. The Empress liked the still life so much that she kept it in her private apartments in the Winter Palace.

Jean-Baptiste Siméon Chardin
1699–1779
France
Still Life with the Attributes of the Arts, 1766
Oil on canvas, 112 × 140.5 cm
Bought from the artist by Catherine II, 1766

Jean-Honoré Fragonard
1732–1806
France
The Stolen Kiss, 1780s
Oil on canvas, 45 × 55 cm
Acquired in 1895;
formerly in the Stanislas
Poniatovsky collection,
Lazienki Palace, Warsaw

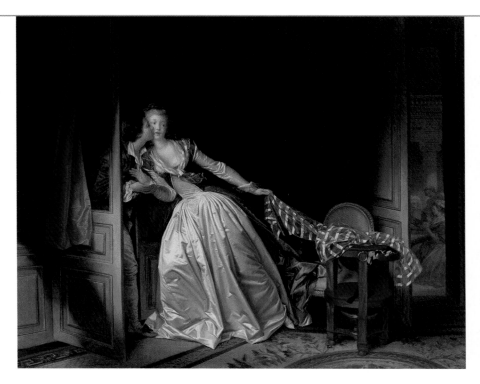

Fragonard was a virtuoso at painting gallant and sentimental scenes where the figures are seen playfully seducing, ignoring or pretending to resist each other. He created this picture in the late 1780s as a continuation of his series on 'Kisses'. It was probably one of a pair – the other half, entitled *The Contract* (or *Consent to Marriage*), seems to have been lost. These paintings, from a mature Fragonard, are the light-hearted, even erotic works for which he is best known, and they reflect the gaiety, frivolity, and voluptuousness of the period.

Demonstrating a mastery of light and shade and using a soft pink-and-green palette, Fragonard admirably renders the details of the interior, the glistening silk of the dress, the transparency of the light scarf, the pattern of the lace and the pink of the cheek (something Fragonard was especially keen on).

It is said that the King Stanislas Ponyatovsky of Poland bought this picture because it reminded him of his 'Russian adventure' – his love affair with Catherine Alexeyevna, the future Catherine II.

(Right) In the mid-eighteenth century Greuze's art was extremely popular. Influenced by the writings of Voltaire and other moral philosophers, his didactic and moralist pictures attuned well to the ideas of the Enlightenment. They were perceived as a protest against Rococo frivolity associated with the excessive splendours and dissolute lifestyle of the king and his court; through them Greuze, championed by Diderot, was aiming at educating people and inspiring them to be virtuous.

The Paralytic Tended by His Children (one of his most famous works), was acquired for Catherine II on Diderot's advice, three years after it was painted.

Jean-Baptiste Greuze
1725–1805
France
The Paralytic Tended by His Children, 1763
Oil on canvas, 115.5 × 146 cm
Bought from the artist by
Catherine II, 1766

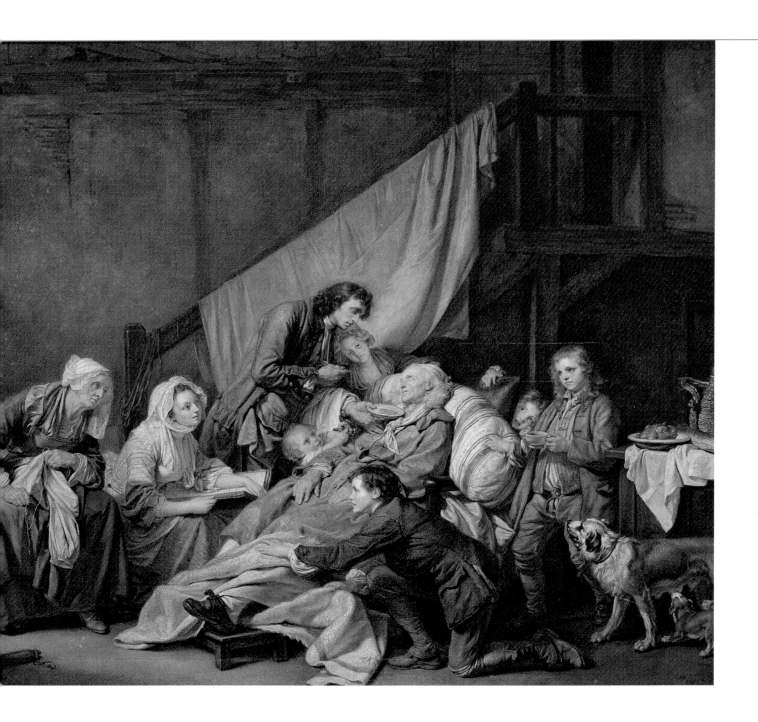

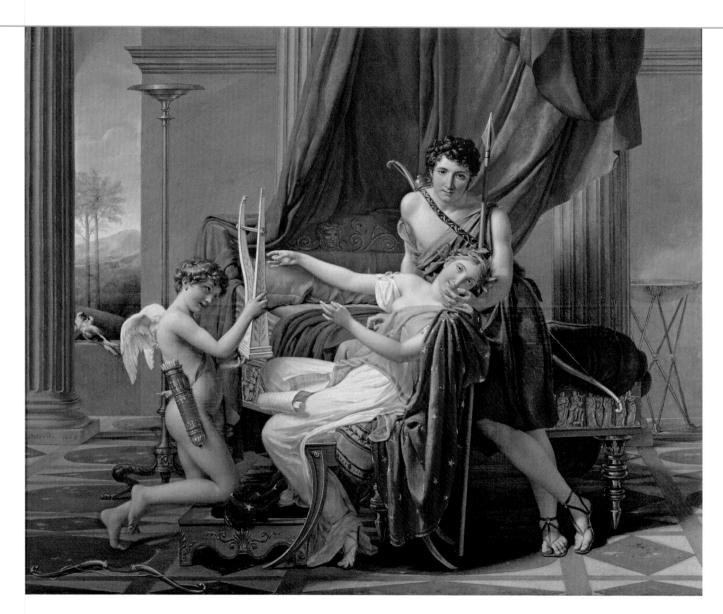

Jacques-Louis David
(1748–1825)
France
Sappho and Phaon, 1809
Oil on canvas, 225.3 × 262 cm
From the Yusupov Palace,
St Petersburg, 1925

(Left) Jacques-Louis David won the Prix de Rome in 1774 and spent the following five years in Italy. A successful portrait and history painter, he was a leading figure in the French Revolution, and, committed to the Napoleonic Empire, he became the official painter to the Emperor in 1804. Following Napoleon's defeat at Waterloo in 1815, David went into exile in Brussels, where he carried on painting.

Sappho and Phaon is the Hermitage's only work by David and it dates from the First French Empire, a period when he had moved away from the classicism intrinsic to his earlier canvases, focusing on Romantic and mythological, rather than heroic, subjects. The work was commissioned by Prince Nikolai Yusupov and illustrates the legend of the Greek poetess Sappho and her love for the beautiful Phaon. Resting on her knees is a scroll inscribed with one of her verses in praise of Phaon; two doves are kissing in the background; Cupid, who clearly embodies voluptuous bliss, plays the lyre for the couple his bow resting on the floor beside him.

(Right) On 17th November 1796, at a battle near Arcole, Italy, the General Bonaparte, as he was at the time, threw himself first into the fray to storm a bridge occupied by the Austrian army, thus moving his soldiers, who had fallen back, forward once more. Napoleon's bold act led to a brilliant French victory.

Antoine-Jean Gros, a pupil of David, left for Italy in 1793. There he was introduced to Napoleon, who, for the next twenty years, would become the heroic subject of Gros's most famous paintings. The artist, who had witnessed the Italian campaign, felt a fearful fascination and devotion for the soldier, qualities that are visible in this romanticized portrayal of the fiery, bold, courageous general. The portrait was brought to Russia by Maximilian, Duke of Leuchtenberg, and was kept in the collection of his son Nicholas.

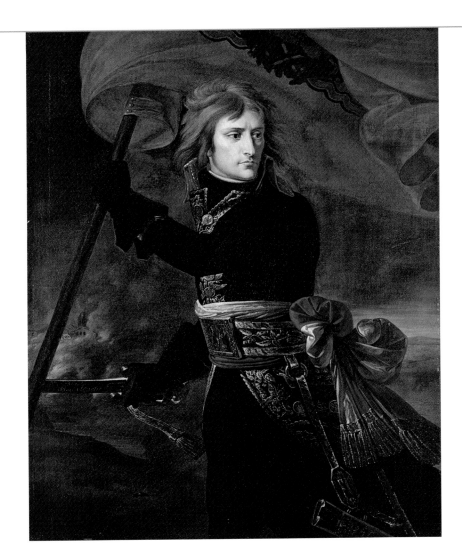

Antoine-Jean Gros
1771–1835
France
Napoleon on the Bridge at Arcole, after 1797
Oil on canvas, 134 × 104 cm
From the State Museum Fund; formerly in the Duke of Leuchtenberg collection, St Petersburg, 1924

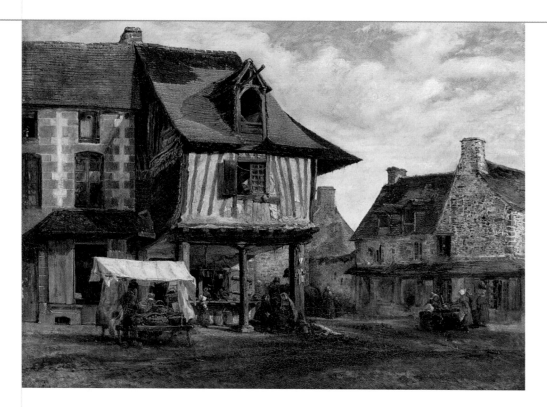

Théodore Rousseau
1812–67
France
Marketplace in Normandy,
c.1832
Oil on panel, 29.5×38 cm
From the Museum of
the Academy of Arts,
St Petersburg, 1922;
formerly in the Kushelev
Gallery, St Petersburg

(Above) Théodore Rousseau passionately loved nature and he started very early to paint landscapes or to copy those by the artists he admired: Claude, the seventeenth-century Dutch painters and Constable. However, his insistence on painting pure landscape, and refusal to insert the conventional human figures or use a mythological angle for his composition, soon earned him the hostility of France's academic establishment. Rousseau, however, persisted and, in the 1830s, he and a group of landscape painters, which included Charles-François Daubigny, Jean-François Millet, Narcisse-Virgile Diaz de la Peña, Jean-Baptiste Corot and Constant Troyon, settled in the village of Barbizon, near Paris. Here they painted the *paysage intime*, or undramatic scenes of peasant life and the countryside, that they saw unfolding around them. Their novel approach marked the beginning of *plein air* painting and the Barbizon School, as they became known, is often considered to have been the forerunner of Impressionism.

(Right) This picture was painted from memory, more than twenty years after Delacroix had spent six months in Morocco, at the court of the sultan Moulay Abd-er-Rahman. The hero of French Romanticism, Delacroix chose big, dramatic subjects filled with strong emotion. However, by the time *Lion Hunt in Morocco* was painted, Romanticism as a coherent art movement was virtually over. Delacroix, alone amongst his contemporaries, remained faithful to the Romantic ideals of his youth – heroism, bravery, drama. Here the mood of the hunters is tense as they lie in wait beneath the branches of a tree; one holds a weapon, an unsheathed sabre lies on the ground, and it seems a matter of seconds before they kill their prey. The colours are vivid with contrasting lush reds and intense greens exploding on the canvas.

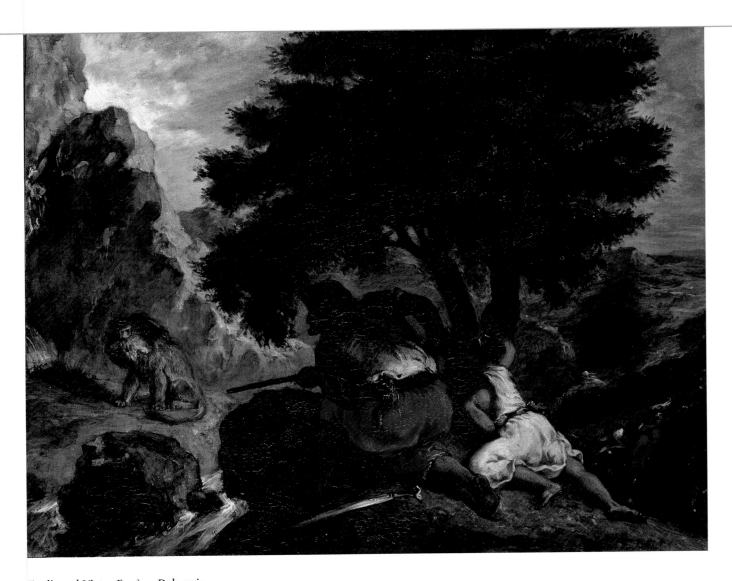

Ferdinand Victor Eugène Delacroix
1798–1863
France
Lion Hunt in Morocco, 1854
Oil on canvas, 74 × 92 cm
From the Museum of the
Academy of Arts, St Petersburg,
1922; formerly in the Kushelev-
Bezborodko Gallery, St Petersburg

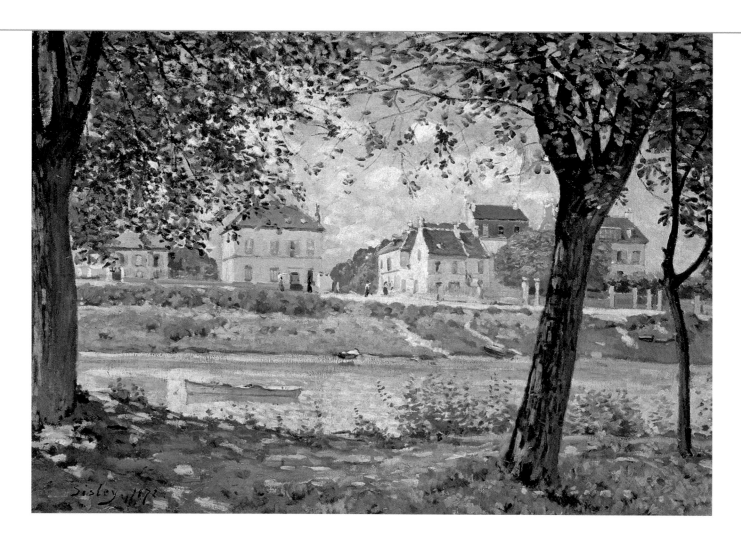

Sisley was nearly exclusively a landscape painter, and, as many of his Impressionist colleagues, only painted the places where he lived or which he knew well. Many of his works are river landscapes, for the relationship between light, water, sky and nature is for an Impressionist nowhere more fascinating.

Villeneuve-la-Garenne was a small town, near Paris, where Sisley often used to go. This canvas belongs to the early period of Impressionism and still conforms to the standards of classical compositions, with the centre of the landscape framed by trees, creating a stage-like effect. Yet the painting simultaneously displays the naturalness that would become the hallmark of an Impressionist work. The 'hero' in the picture is the vivid sunlight illuminating the buildings, seen from the shade beneath the trees. With a fine lyrical sense Sisley successfully captures the modest charm and gentle beauty of nature; the feeling of cool air, contrasting with the still heat of the opposite bank, is almost tangible.

The two houses on the left of this picture were also shown on the right half of the landscape Bridge at Villeneuve-la-Garenne (Metropolitan Mseum of Art, New York) as if Sisley were carrying on the panorama that he begun here.

Alfred Sisley
1839–99
France
Villeneuve-la-Garenne
(*Village on the Seine*), 1872
Oil on canvas, 59 × 80.5 cm
From the State Museum
of Modern Western Art,
Moscow, 1948; formerly
in the Peter and Sergei
Shchukin collection,
Moscow

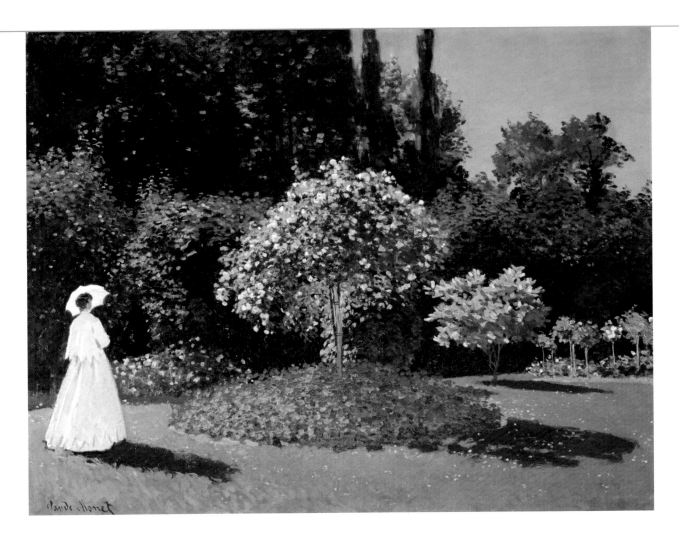

This masterpiece of early Impressionism is by the group's leader, Claude Monet. The sunlight that floods the paintings of the Impressionists – who did most of their painting out of doors, working directly from nature – here plays the central role.

Monet spent his childhood in Le Havre, which he periodically visited. The Le Coteaux estate at Sainte-Adresse, a small town on the Channel coast of Normandy, just north of Le Havre, belonged to Monet's cousin, Paul-Eugène Lecadre. Monet spent the summer of 1867 there and painted several landscapes in the garden of the estate, of which *Lady in the Garden* is the most important. Dressed in the fashion of the day, the model for the female figure was Jeanne-Marguerite Lecadre, the wife of Monet's cousin. This solitary silhouette introduces an elegaic, sorrowful note into the painting, while the bright, light area of the dress plays an important role in balancing the composition and in demonstrating the interrelationship of light and colour.

Claude Monet
1840–1926
France
Lady in the Garden
(*Sainte-Adresse*), 1867
Oil on canvas, 82.3 × 101.5 cm
From the State Museum of
Modern Western Art, Moscow,
1930; formerly in the Sergei
Shchukin collection, Moscow

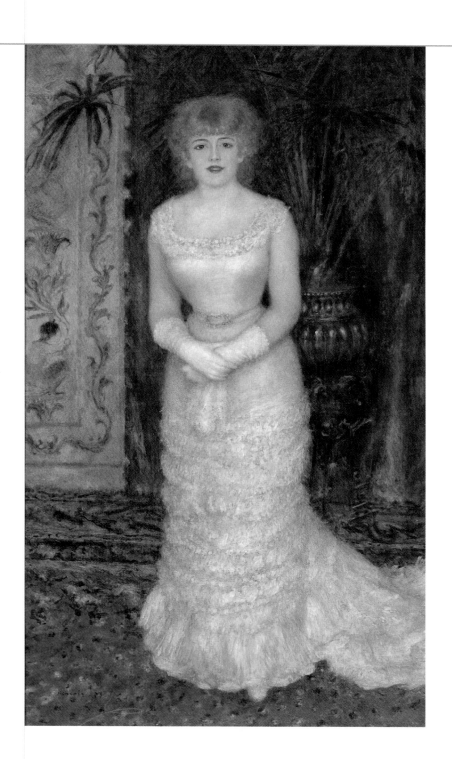

When, in 1877, Renoir finally managed to get some of his portraits accepted by the official Paris Salon, they were received with great acclaim by the public. Renoir then stopped exhibiting with the Impressionists, as the opportunities offered to him as a result of a successful Salon were far greater than those he could gain by staying with his original, but somewhat controversial, fellow colleagues.

Jeanne Samary (1853–90) was a successful French actress, who played the parts of maids and soubrettes in Molière's comedies at the Comédie-Française in Paris. According to the Renoir's son, this work, one of the most important paintings Renoir made of the actress, was commissioned by Samary's parents, Renoir's next-door neighbours. It was also painted in time to be shown at the Paris Salon of 1879, and this may explain why its composition is more conventional than in the previous portraits of the actress. It does, however, manage to avoid the stiffness or artificiality typical of Salon painting: Jeanne looks natural and graceful, gazing intently at the beholder, with a shadow of a smile playing on her lips.

Pierre-Auguste Renoir
1841–1919
France
Portrait of the Actress Jeanne Samary, 1878
Oil on canvas, 174 × 101.5 cm
From the State Museum of Modern Western Art, Moscow, 1948; formerly in the Ivan Morozov collection, Moscow

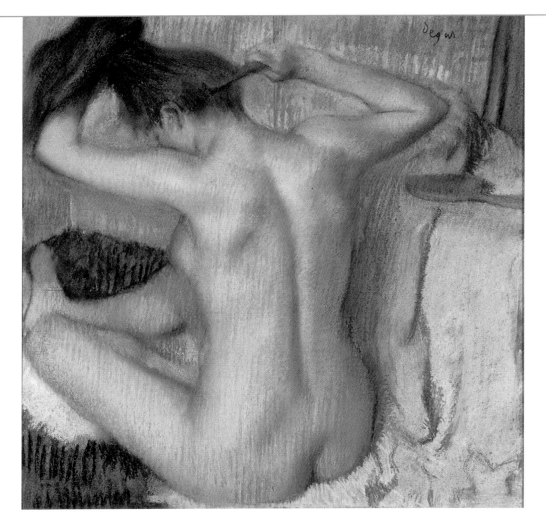

Edgar Degas
1834–1917
France
*Woman Combing
Her Hair*, 1885
Pastel on cardboard,
53 × 52 cm
From the State Museum
of Modern Western Art,
Moscow, 1935;
formerly in the Sergei
Shchukin collection,
Moscow

Degas was one of the greatest draughtsmen of all time. Unlike other Impressionists,
he emphasized composition and drawing and his primary concern was in depicting movement.
This may explain his fascination for women in all their different roles: as cabaret singers, ballet
dancers, waitresses, or as bathers, as he portrayed them for almost thirty years, washing and
drying themselves, combing their hair or having it combed. "The nude has always been portrayed
in postures that presuppose an audience", he once said. "But my women are simple, straight-
forward women, concerned with nothing beyond their physical existence... It's as though one
were peeping through a keyhole".

This is one of the most harmonious and innovative of Degas' series of pastel nudes. The woman's
body is gently outlined through light and colour, the composition deeply innovative in its absence
of depth, flat background and the use of a constricting frame for such a large figure.

In the 1880s Van Gogh moved from Paris to
Arles in the south of France. There under the
blazing Provence sun he painted daily two or three
pictures from nature, working in a state of extreme
tension and anxiety. His paintings are built upon
decorative patches of colour, each dynamic and
instictive stroke having its own importance.

Van Gogh believed that an artist should only be
preoccupied with the difficult task of expressing
his inner feelings on the canvas, and not worry
about the characterization of the depicted subjects.
In this belief lies the artist's aesthetic, the source
of the intensity of lines and colours found in each
his expressive pictures. Van Gogh left a deep mark
on twentieth-century art, particularly Fauvism and
Expressionism, and is today one of the world's
best-known and best-loved painters.

Vincent van Gogh
1853–90
France
*Memory of the Garden
at Etten* (*Women of Arles*), 1888
Oil on canvas, 73 × 92 cm
From the State Museum
of Modern Western Art,
Moscow, 1948; formerly
in the Sergei Shchukin
collection, Moscow

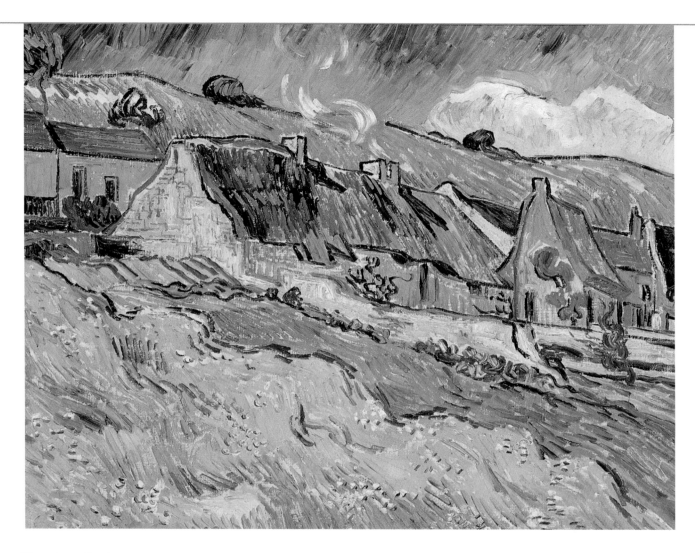

Vincent van Gogh
1853–90
France
Thatched Cottages, 1890
Oil on canvas, 59.5×73 cm
From the State Museum of
Modern Western Art, Moscow,
1948; formerly in the Ivan
Morozov collection, Moscow

(Left) This is one of the first landscapes Van Gogh painted when he arrived at Auvers-sur-Oise, a small town north of Paris, in 1890, for what were to be the last few months of his life. There he placed himself in the care of Dr Paul Gachet, who had long been interested in both psychiatry and the arts and whom Van Gogh would paint many times. During the months he spent at Auvers he was immensely prolific. At the beginning of June he wrote to his sister: "There are some roofs of mossy thatch here which are superb and of which I shall certainly make something". He had already made a number of paintings and drawings of thatched roofs in Holland in the 1880s, and he returned to this motif when he was living in Saint-Rémy and last, in Auvers. The hurried style that is so instantly recognisable, the avalanche of frenzied brushstrokes surging upwards (the sky) and downwards (the cottages) are a moving sign of his tormented sensibility and perception of life and the world.

(Right) Financial considerations curtailed Gauguin's first stay in Tahiti (1891–93), but he returned in 1895 and remained in the islands until his death in 1903.

Gauguin saw the South Seas as a 'promised land', a harmonious world unspoiled by civilization. The woman in this painting (Gauguin's Tahitian wife Tehemana) can be seen as the Eve of Oceanian Paradise. The fruit she is holding is a water vessel made of pumpkin and a symbolic attribute, water being a Tahitian symbol of life. The title of the picture can be translated as 'Where are you going?'.

In the 1880s and 1890s Gauguin developed a highly personal style marked by simplified forms, decorative line and flat, curving shapes of vivid and expressive colour, all of which can be seen here.

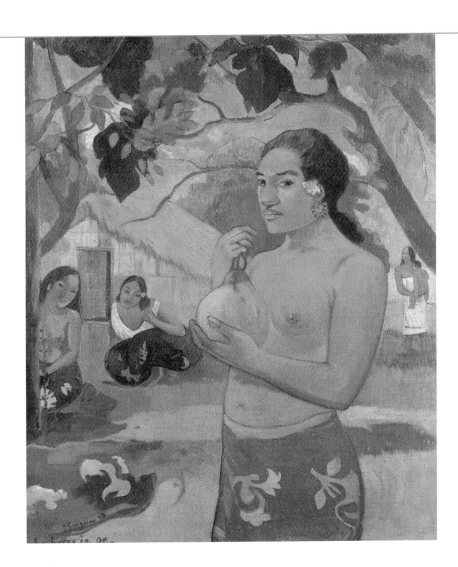

Paul Gauguin
1848–1903
France
Eu haere ia oe (Woman Holding a Fruit), 1893
Oil on canvas, 92 × 73.5 cm
From the State Museum of Modern Western Art, Moscow, 1948; formerly the Ivan Morozov collection, Moscow

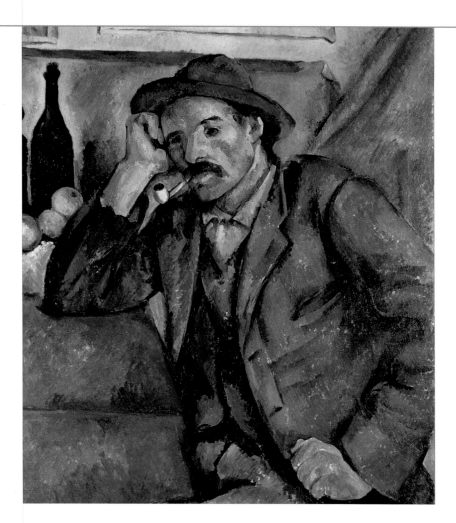

Paul Cézanne
1839–1906
France
The Smoker, 1890–92
Oil on canvas, 92.5 × 73.5 cm
From the State Museum
of Modern Western Art,
Moscow, 1931; formerly in
the Ivan Morozov collection,
Moscow

Paul Cézanne is often called the 'father of modern painting'. His extraordinary work in the realm of colour and form exerted a decisive influence on the development of Post-Impressionism and early Cubism.

This portrait of a Provence peasant with a pipe, *The Smoker*, is one of a series of smokers and card players that Cézanne painted in the early 1890s. The subject can be linked to the genre paintings of the Old Masters back in the seventeenth century and Cézanne uses it to embody the idea of aloofness from everyday concerns, drawing attention to the calm and solid pose of his character. It is not a psychological study: Cézanne does not even draw in the eyes and the face of the sitter is devoid of expression, thus the painting goes beyond individual expression to attain a three-dimensional majesty. "Most of all," said Cézanne, "I love the appearance of those who have aged without ever changing their habits". Such is the hero of this work. Two other versions of *The Smoker* can be found in the Pushkin Museum of Fine Arts, Moscow, and in the Kunsthalle, Mannheim (Germany).

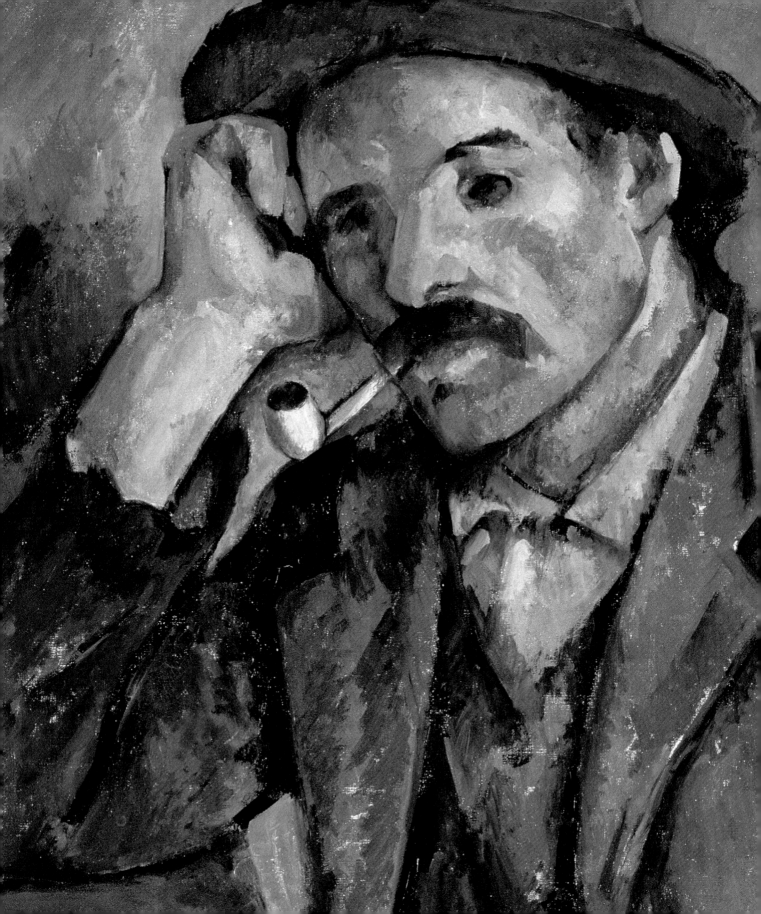

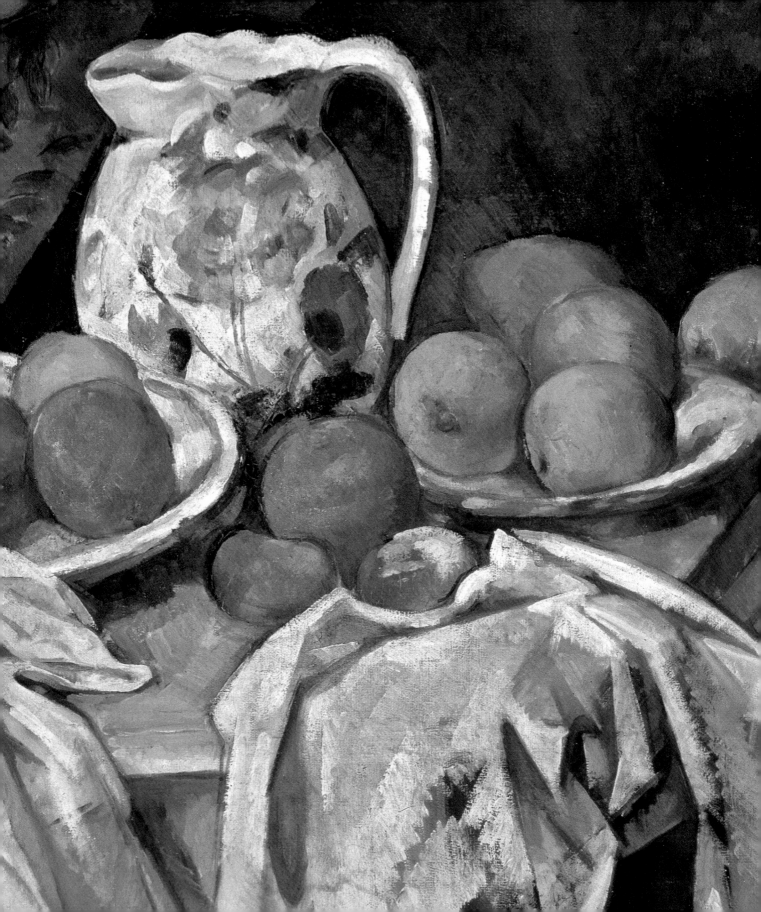

Paul Cézanne was fascinated by still lifes and painted more than two hundred in his lifetime. Using a repertoire of everyday objects such as fruit, jugs, bottles, plates and flowers, he experimented with relationships of form, colour and pattern. Although the groupings always seem casual, Cézanne is known to have taken great care with the arrangement, sometimes spending hours positioning the objects.

The harmonious colour range and the perfectly balanced composition of this work make it one of Cézanne's greatest paintings. The fruit is a perfect example of how form is born out of colour and tone; through small, precise brushstrokes of pure colour the objects are given a three-dimensional life, a sculptural weight and volume. For Cézanne, a painting was not an illusion but a physical representation on a canvas and central to him was the desire to give sculptural weight and volume to the immediacy of vision achieved in their work by the Impressionists.

Paul Cézanne
1839–1906
France
Still Life with Drapery,
1894–95
Oil on canvas, 55 × 74.5 cm
From the State Museum
of Modern Western Art,
Moscow, 1930; formerly in
the Ivan Morozov collection,
Moscow

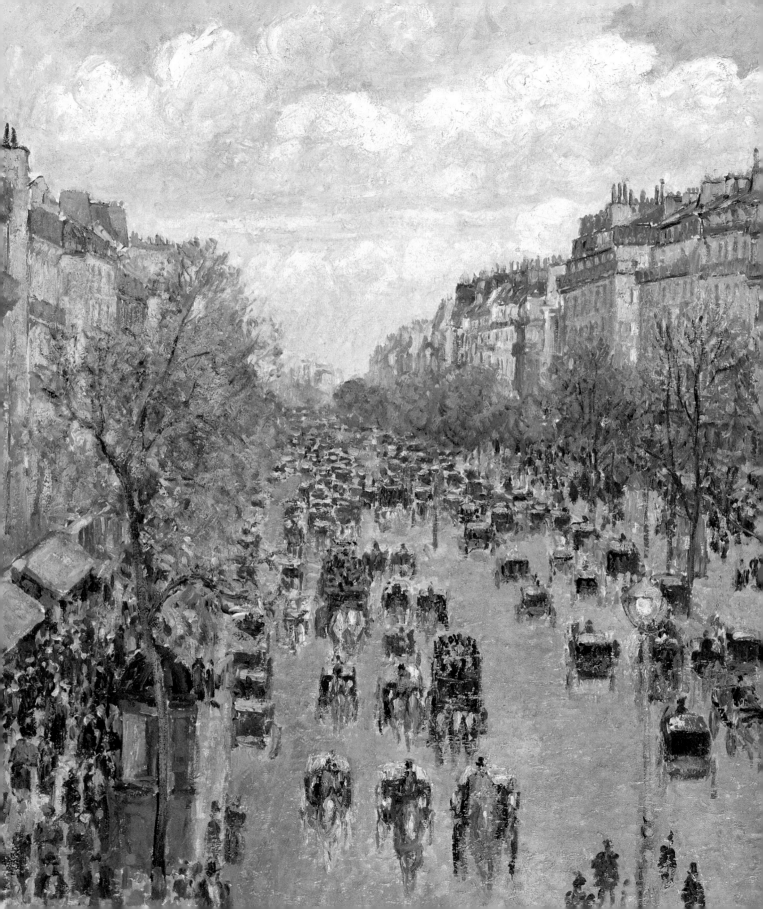

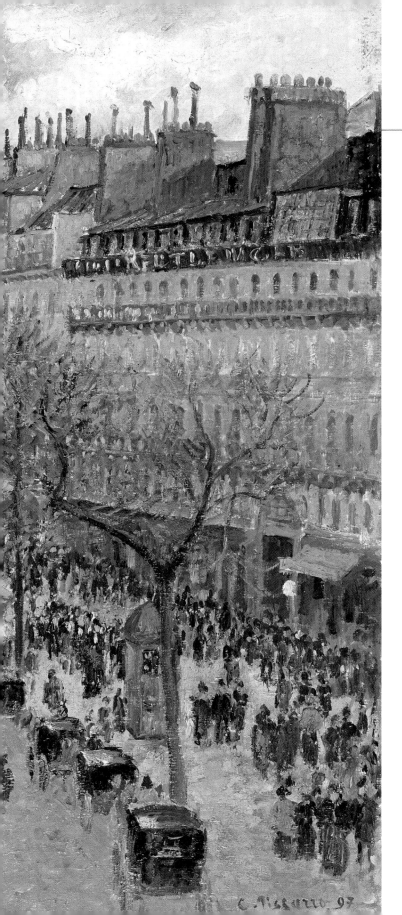

In the winter and spring of 1897 Pissarro worked on a series of cityscapes entitled 'Boulevards of Paris' and presenting the image of contemporary city life. The series attracted the attention of critics, who linked his name with a painting technique known as Divisionism, in which colour effects are obtained optically rather than by mixing pigments on the palette.

Pissarro often chose high viewpoints to work from: for the Boulevard Montmartre, where his rapid brushwork convincingly captured the fast-moving, animated aspect of urban life on the boulevards, he made sketches from the window of a rented room in the Hôtel de Russie, taking the sketches back to his studio at Eragny to finish them. This series (a total of thirteen paintings) is the only one in Pissarro's oeuvre in which he depicts the same scene at different hours of the day and in different weather conditions.

Camille Pissarro
1830–1903
France
Boulevard Montmartre in Paris, 1897
Oil on canvas, 73 × 92 cm
From the State Museum of
Modern Western Art, Moscow, 1948;
formerly in the M. Riabushinsky
collection, Moscow

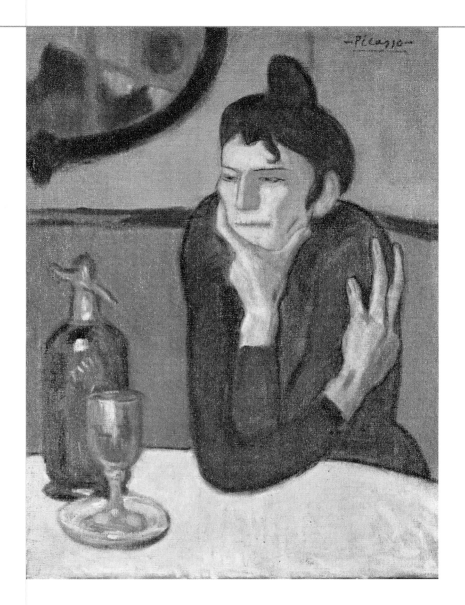

Born in Málaga, Picasso studied at the Academy of San Fernando in Madrid and associated with a circle of Barcelona artists and poets whose favourite meeting-place was the Four Cats cabaret. Picasso visited Paris for the first time in October 1899. It was during his second visit, in 1901, that he painted *The Absinthe Drinker*, a work belonging to what is known as his Blue period (1901–4). Already, during his years in Barcelona, Picasso had started to be fascinated by the subject of a woman sitting alone in a café; man's sense of isolation and emptiness were recurrent themes in the works of contemporary artists he admired: Degas and Toulouse-Lautrec.

Here, our heroine sits alone at a table, her chin resting in her hand, lost in thoughts, the background a dirty-red wall reinforcing a sense of discomfort. Emphasizing the flatness of the canvas, the colour of the walls and the bluish tone of the marble table seem to press the space inwards, around the woman, enclosing her in a hopeless isolation. In the pose of the absinthe drinker we can identify the outcast: Picasso strictly boxes in the immobile and expressionless face – the left hand acts as a support, its precise perpendicular running through the imperfect oval of the figure, while the right hand, clasping the shoulder, seems to protect and enclose the space of her body. Everything reinforces the sense of a figure cut off from the world, who experiences internally the tension of a tightly coiled spring.

Pablo Picasso
1881–1973
France
The Absinthe Drinker, 1901
Oil on canvas, 73 × 54 cm
From the State Museum
of Modern Western Art,
Moscow, 1948; formerly
in the Sergei Shchukin
collection, Moscow

In 1904 Picasso finally moved to Paris and settled in Montmartre. From then until the beginning of 1906, his work focused on a single theme: the saltimbanque, or travelling circus artist. This stage in his artistic life is known as his Pink period, when his paintings became less melancholic and austere, leaving the world of the poor and unfortunate to depict a more lyrical and playful one.

Boy with a Dog belongs to the very beginnings of the period and there is still a poignant melancholy in the figure of this young boy. It closely resembles a larger gouache, *Two Acrobats with a Dog* (Museum of Modern Art, New York), which is generally believed to be a direct response to Charles Baudelaire's verse, *Les Bons Chiens*:
"I sing the dirty dog, the poor dog, the homeless dog, the stray dog, the dog saltimbanque, the dog whose instinct, like that of the beggar, the bohemian and the comedian, is so wonderfully sharpened by necessity, this kind mother, this real patron of all intelligence!"

Pablo Picasso
1881–1973
France
Boy with a Dog, 1905
Gouache and pastel on cardboard, 57 × 41 cm
From the State Museum of Modern Western Art, Moscow, 1948; formerly in the Sergei Shchukin collection, Moscow

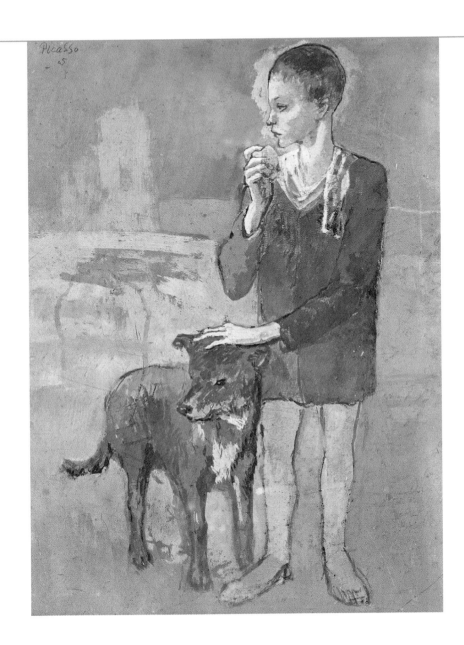

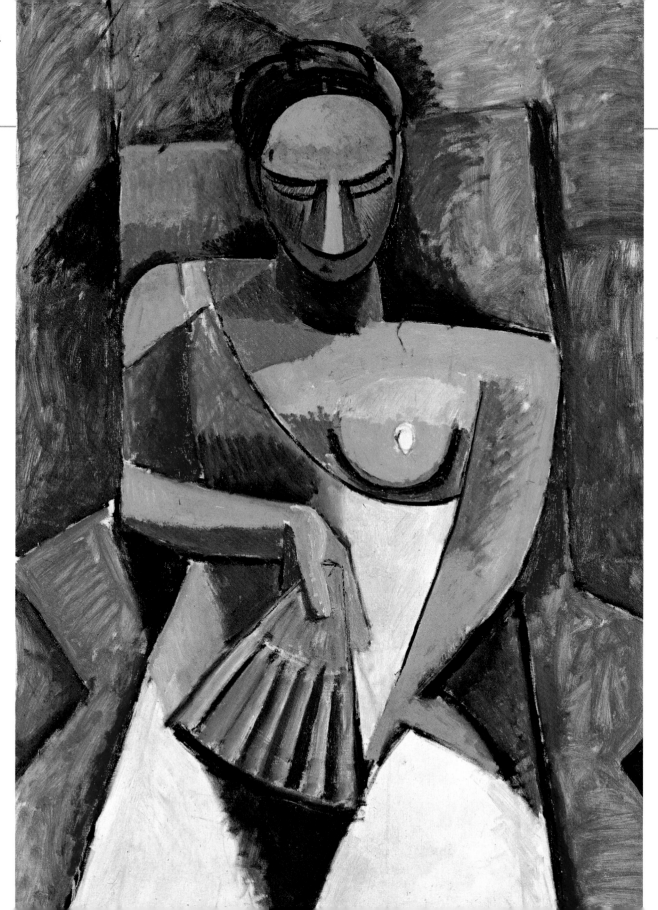

Cubism was possibly the most influential movement in twentieth-century art, and was the result of a unique collaboration between Pablo Picasso and Georges Braque. It was an attempt to render three-dimensional forms on a two-dimensional surface in a radical break from traditional composition and perspective. By fragmenting the volumes into flat, angular facets or planes, the artist manages to imply multiple, simultaneous views of the object or figure.

There were two main phases in the developement of Cubism. The first phase of the movement was inspired by Cézanne and is referred to as Analytical Cubism (1908–11). This is when Picasso and Braque broke down the subjects painted into multiple geometrical facets with subdued colours. The second phase is called Synthetic Cubism (1911–14).

Woman with a Fan dates from the early stages of Analytical Cubism. The modelling and colour scale of this portrait reveals the painter's familiarity with African art. Here Picasso applies the exploration of geometric representations that culminated in his monumental *Three Women*, painted the same year as *Woman with a Fan* and also in the Hermitage.

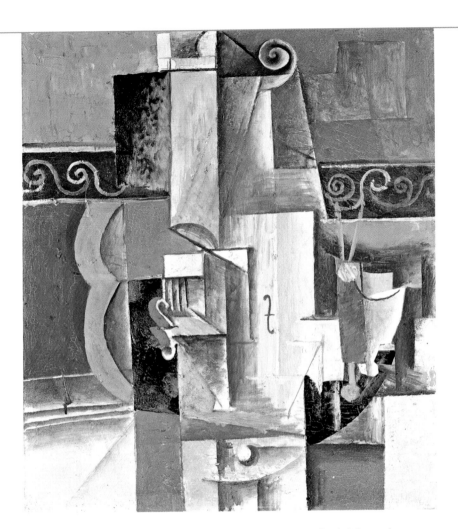

Pablo Picasso
1881–1973
France
Woman with a Fan
(*After the Ball*), 1908
Oil on canvas, 150 × 100 cm
From the State Museum
of Modern Western Art,
Moscow, 1934; formerly
in the Sergei Shchukin
collection, Moscow

Pablo Picasso
1881–1973
France
Guitar and Violin, 1913
Oil on canvas, 65 × 54 cm
From the State Museum
of Modern Western Art,
Moscow, 1948; formerly
in the Sergei Shchukin
collection, Moscow

Synthetic Cubism involved richer colours, collages, stencil lettering and pasting actual pieces of cloth or paper onto the canvas. Between 1912 and 1914 Picasso produced a large number of 'synthetic' compositions on the theme of music and musical instruments. *Guitar and Violin* is one of them.

Matisse's first one-man show was organised by Ambroise
Vollard in 1904. At the Paris Salon d'Automne of 1905, the
works of a number of artists were hung together in the seventh
hall. The paintings had such vibrant colours and seemingly
'primitive' handling of paint that one critic dubbed the room
'a cage of wild beasts' (*fauves* in French): the name stuck.
Matisse came to be regarded as the leader of the new Fauvist
movement, and would say later: "Fauve painting is not
everything, but it is the foundation of everything". The majority
of his oeuvre consists of monumental decorative compositions
that explore the realm of colour in the unique way that makes
him one of the most important painters of the twentieth
century. His works are permeated with bright saturated colours
in the most unusual combinations.

In this work, dating from 1911, Matisse endeavoured to depict
a genre scene: his wife Amélie is doing embroidery, his
daughter Marguerite is entering the room and his sons Pierre
and Jean are playing draughts. The structure of this large
canvas is unusual. Matisse takes us into a world of whimsical
patterns and lines, whether childishly naive or of oriental
complexity. The squares of the chessboard in the centre link
together the oriental carpet, the four figures and the ornament
on the mantelpiece. But the most important element is, of
course, colour. The most conspicuous spots of colour are, as
often in Matisse's work, contained in the figures – the red of
the boy's clothes and the black of the girl's dress. Working on
this type of complicated composition, Matisse drew inspiration
from Persian miniatures, acknowledging that they had enabled
him to go 'beyond intimate painting'.

Henri Matisse
1869–1954
France
The Artist's Family, 1911
Oil on canvas, 143 × 194 cm
From the State Museum
of Modern Western Art,
Moscow, 1948; formerly
in the Sergei Shchukin
collection, Moscow

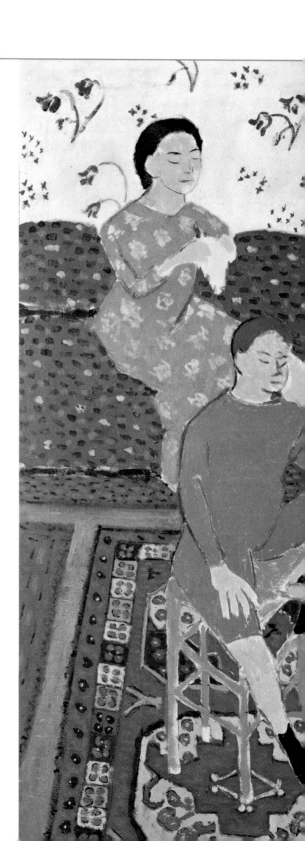

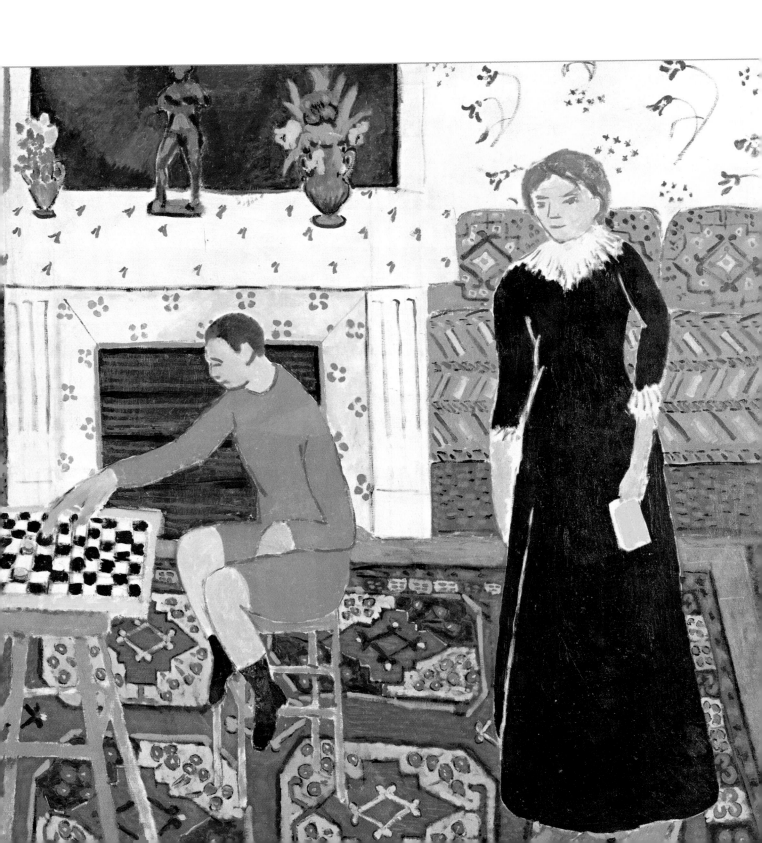

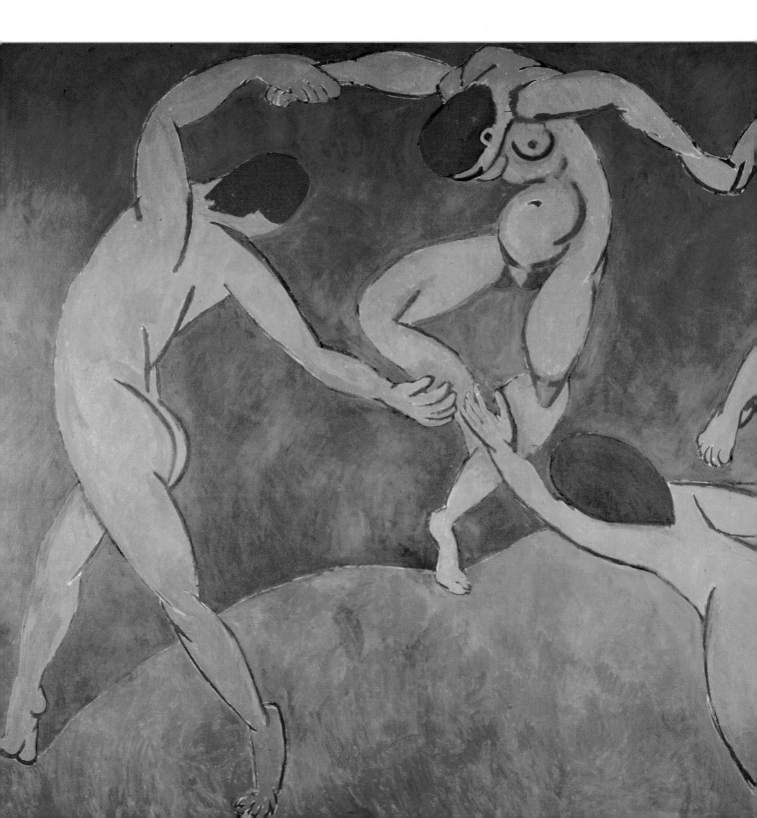

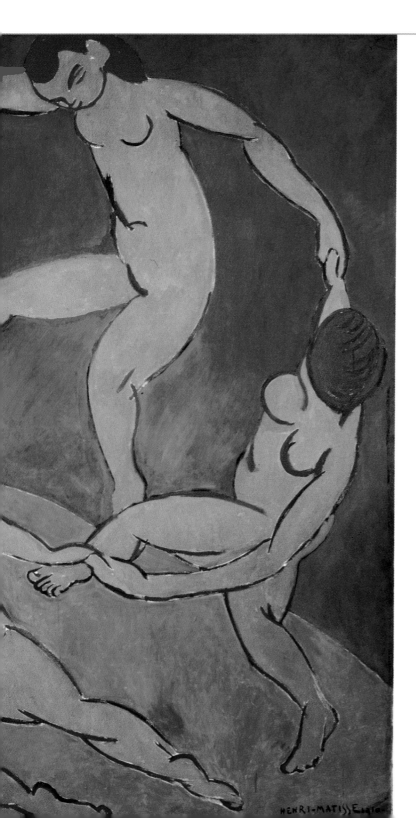

The pair of panels known as *Dance* and *Music* (also in the Hermitage) are amongst Matisse's most important – and most famous – works. They were commissioned in 1910 by one of the leading Russian collectors of French late nineteenth and early twentieth-century art, Sergei Shchukin. Until the Revolution of 1917, they hung on the staircase of his Moscow mansion.

The sources of Matisse's *Dance* are various. As Matisse himself recollected, the dance motif was prompted by the farandole he had watched on the dancefloor of the Moulin de la Galette in Paris. The theme can also be traced back to his painting of 1905, *Joie de Vivre*, in which a group of dancers whirl around in the background. It is a monumental image of joy and energy, and also strikingly daring, intense in colour. With their sinewy and energetic bodies, these are no ordinary dancers, but mythical creatures in a timeless landscape. Dance, Matisse once said, meant 'life and rhythm'. The frenzied rhythm of the pagan bacchanalia is embodied in the powerful, stunning accord of red, blue and green, uniting Man, Heaven and Earth. An earlier version of *Dance*, almost identical in composition, hangs in the Museum of Modern Art in New York.

Henri Matisse
1869–1954
France
Dance, 1909–10
Oil on canvas, 260 × 391 cm
From the State Museum of Modern Western Art, Moscow, 1948; formerly in the Sergei Shchukin collection, Moscow

NORTHERN PAINTING

Netherlandish, Flemish and Dutch schools

Anthony van Dyck
1599–1641
Flanders
Portrait of a Lady
with a Tulip (Portrait
of Jane Goodwin), 1639
(detail)

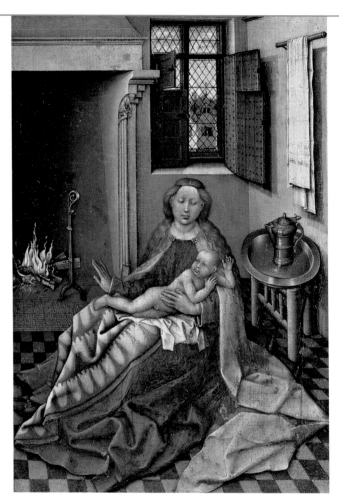

Robert Campin
(Master of Flémalle)
*c.*1380–1444
The Netherlands
The Holy Trinity; Madonna
and Child before the
Fireplace, diptych, 1430s
Oil on panel, 34.3 × 24.5 cm
(each panel)
From the Dmitry Tatishchev
collection; presented by the
heirs in 1845

Robert Campin was probably among the first of the Netherlandish artists to master the technique of oil painting. This diptych is the only work by Campin exhibited in the Hermitage and is devoted to the two principals of Christianity: incarnation (Christ as a child) and redemption (his death for the sake of mankind). In keeping with the religious thinking of the fifteenth century, Campin imbued all details of the composition with a symbolic meaning.

In *The Holy Trinity*, the Christian Church and the Synagogue are symbolised in the form of high-reliefs on the arms of the throne (left and right respectively). Over the left arm is a pelican feeding its young on its own blood, a symbol of Christ's self-sacrifice and of communion; over the right arm is a lioness bending over her cubs. This latter image refers to the treatise *Physiologus*, which tells the legend of how a lioness gave birth to dead cubs, which were brought back to life three days later by their father's roars. Medieval theologians saw here an image of Christ's temporal death and resurrection three days later on his father's command.

In the *Madonna and Child before the Fireplace*, the human and the heavenly mingle as the Madonna and child are set in the contemporary interior of a typical Netherlandish burgher's home and acquire a down-to-earth, realistic, tone, tempered by the Madonna's rich attire, as suited to her divine status. The technique of oil painting enabled the artist to achieve an amazing resonance of colours and to create the subtlest of gradations and nuances.The smallest details are meticulously rendered, from the cloth hanging on the rail to the small houses visible through the window.

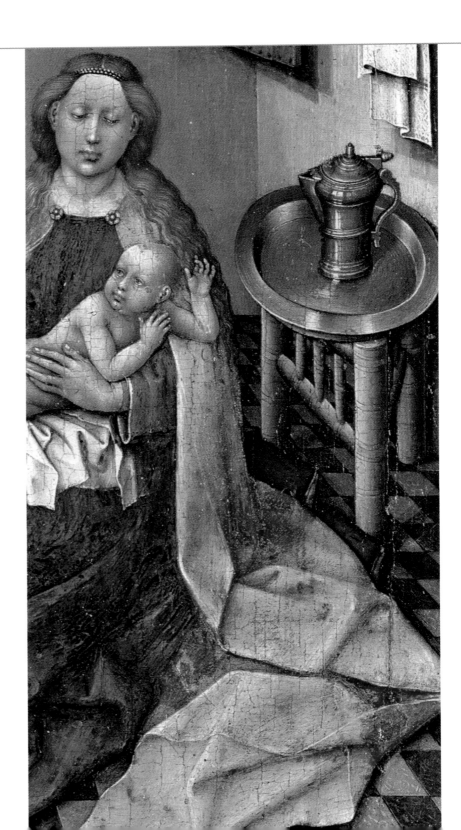

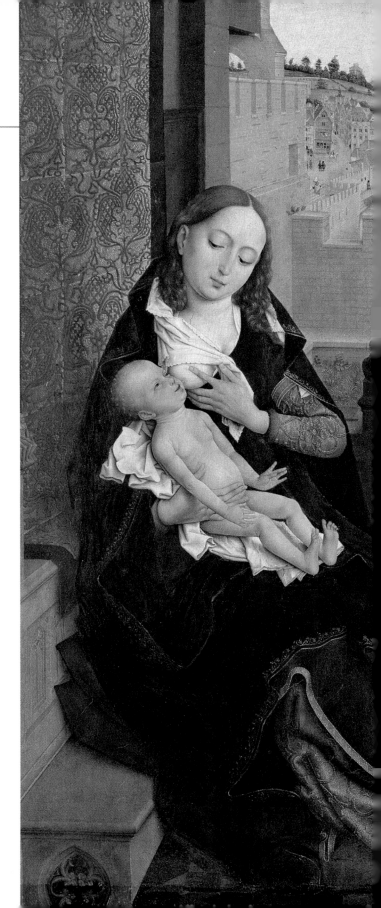

This panel was housed in a Spanish monastery until 1813, during which time it was cut in half. In 1850, the right-hand section (bearing the image of St Luke) was purchased by the Hermitage at the sale, in The Hague, of the collection belonging to King William II of the Netherlands. The left-hand section (featuring the Virgin) was in the Paris collection of Baron de Beurnonville, who put it up for sale in 1884. That same year the Hermitage bought it from the art-dealer Baer and the two parts of the panel were reunited.

According to a sixth-century legend, St Luke was in the process of drawing a picture of the Virgin when she miraculously appeared before him. He thus became the patron saint of painters. St Luke's guilds used to decorate their conference-halls and chapels with pictures showing individual episodes from the life of their patron saint: this one was executed by Van der Weyden for the chapel of the Guild of Brussels Painters. The composition of this piece was very popular at the time and the artist did several similar versions of this work, the best of which are in Bruges, Munich and Boston.

Rogier van der Weyden
*c.*1400–64
The Netherlands
*St Luke Drawing
a Portrait of the Virgin*
Oil on canvas (transferred
from panel), 102.5 × 108.5 cm
Acquired through A. Baer,
St Petersburg, 1884

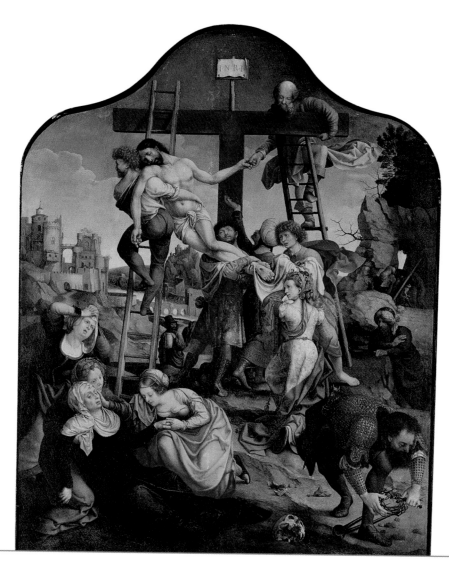

Mabuse (Jan Gossaert)
*c.*1478–1532
The Netherlands
The Descent from the Cross, 1524
Oil on canvas (transferred
from panel), 141 × 106.5 cm
From the William II collection,
The Hague, 1850

The *Descent from the Cross* was the central
part of an altar triptych painted for the chapel
of the Church of St Augustine in Bruges.
From 1837 to 1850 it hung in the William II
collection, The Hague, and in 1850, along
with the rest of his collection, was bought for
the Hermitage. The wings of the triptych,
however, found their way to the USA.

In 1508 Gossaert went to Italy with his
patron Philip of Burgundy and came back
with new ideas that revolutionised
Netherlandish painting. Thus, Romanism
was born, a trend in Netherlandish art which
combined Italian Renaissance elements with
Flemish traditions. In this particular work
scholars have observed the influences of
Mantegna, Raphael and Michelangelo. The
composition is centralised and balanced, but
seems to be divided into separate elements.
In the foreground are Joseph of Arimathea
with Christ's crown of thorns, and the Holy
Women, one of whom is wringing her hands
in grief while the other two bend over the
unconscious Madonna. Amongst the pupils
and followers of Christ we see Mary
Magdalene and the young John the Evangelist
at the foot of the Cross. The Italian influence
is clearly felt in the way in which Mabuse
gives the bodies of his subjects a sculptural
feel, through a deliberately complex
foreshortening – these are technical skills
that he could have only learned in Italy.
However, the nature of the landscape and the
naturalistic treatment of the clothes, jewellery
and everyday objects are linked with the
traditions of the Netherlandish school of
painting. The image of St John is said to be
that of Don Pedro da Salamanca, the patron
who commissioned the triptych, while
St Peter is a self-portrait of the artist.

This painting was executed in 1524 for the Church of St Donatian in Bruges. During the religious troubles of the 1560s, it was hidden in the cathedral wall for safekeeping and subsequently forgotten. It was only recovered two hundred years later, in 1795, when the French demolished the church, knocking down the walls and revealing the treasure hidden within them. The canvas found its way to the collection of William II of the Netherlands and in 1850, along with the king's other canvases, was acquired for the Hermitage.

Provost was a gifted northern Renaissance painter of altarpieces and *The Virgin in Glory* is one of his finest works: its modelling is delicate, its drawing precise, like a miniaturist's work, but mostly it exudes sublime spirituality, largely due to the solemn image of the Virgin, standing on a half-moon, surrounded by a golden aureole, tenderly pressing the Christ Child to her breast. On either side of her stand King David, playing the harp, and the Roman Emperor Augustus, who had a vision of the Virgin and Child: the sibyls are surrounded by angels, and in the hands of the Persian Sibyl is a scroll bearing the inscription 'The womb of the Virgin will bring Salvation to humankind'. While the upper part of the composition is treated in the tradition of medieval painting, the lower part shows the influence of Italian artists, in the complex foreshortenings of the figures, for example, and in the magnificent handling of light and shade.

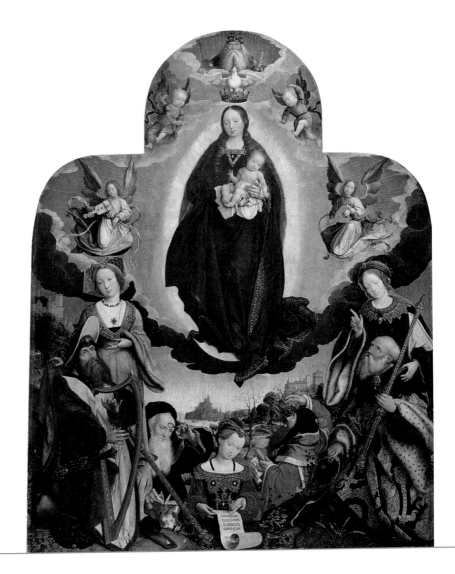

Jan Provost
*c.*1465–1529
The Netherlands
The Virgin in Glory, 1524
Oil on canvas (transferred
from panel), 203 × 151 cm
From the William II collection,
The Hague, 1850

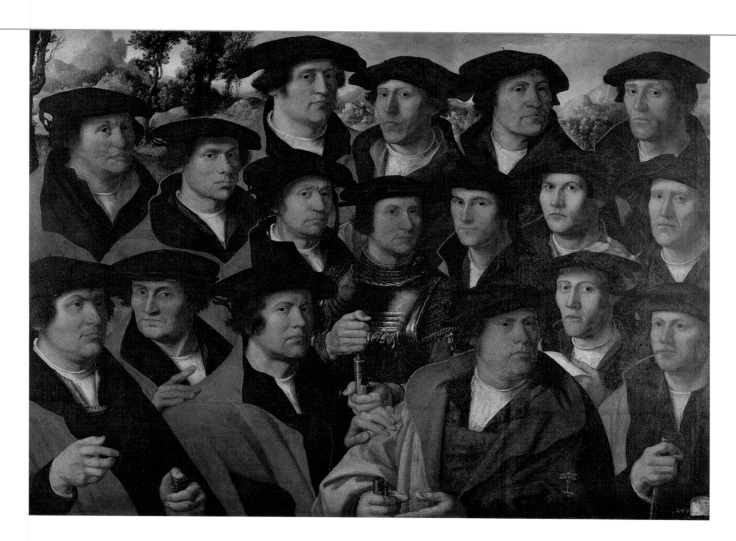

This is one of the earliest examples of a group portrait in the Netherlands.
The genre only took shape in Netherlandish painting in the sixteenth-century
and became widely used by the artists of the country's northern provinces.
The marksmen are shown wearing their society uniform: a red and blue cloak
and a flat black cap. The composition is rather unconventional in the way the
figures are arranged in three rows, one behind the other, with the individuals
standing shoulder to shoulder so they fill the entire pictorial space. It is possible
that the order of this multifigured composition was pre-arranged, as each
marksman would have paid Jacobsz, and the amount received would have
determined the row in which the sitter would be placed – the first row being,
naturally, the most expensive.

Dirck Jacobsz
c.1497–1567
The Netherlands
*Group Portrait of the
Shooting Corporation
of Amsterdam,* 1532
Oil on canvas (transferred
from panel) 115 × 160 cm
From the Heinrich
von Brühl collection,
Dresden, 1769

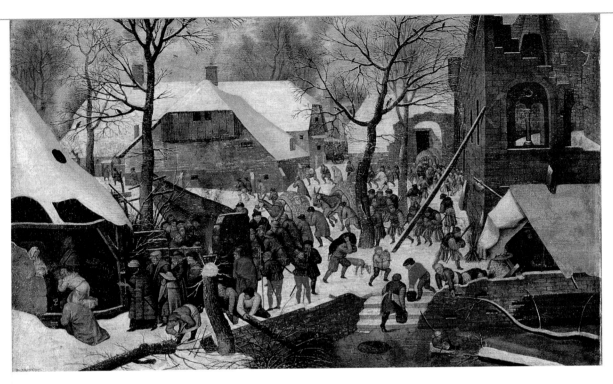

Pieter Brueghel the Younger was the elder son of the great sixteenth-century Netherlandish painter Pieter Bruegel the Elder (*c.*1525–69), sometimes also called 'Peasant Bruegel'. The father was active mainly in Brussels, and his oldest son was among those who contributed most to the distribution of the father's work. At the head of a very productive workshop, Brueghel the Younger produced many copies of his father's paintings: this is one of them – the original hangs in the Reinhard collection in Winterhur, Switzerland.

The religious subject of *The Adoration of the Magi* is treated as an unusual event in the life of a small, wintery, Netherlandish town. The central episode of the Adoration, the birth of Christ, takes place not in the centre of the picture but to one side, and is almost lost amongst the many other events, most of them relating to everyday chores such as chopping wood, carrying water and hunting. Brueghel's realism and love of his native countryside, which he painted at all the different times of the year, is seen in his obvious powers of observation, and the documentary-like knowledge and minutiae with which he depicts his characters and their tasks.

Pieter Brueghel the Younger
*c.*1564–1638
The Netherlands
The Adoration of the Magi
Oil on canvas (transferred from panel), 36 × 56 cm
Transferred from the Academy of Arts Museum, St Petersburg, 1922

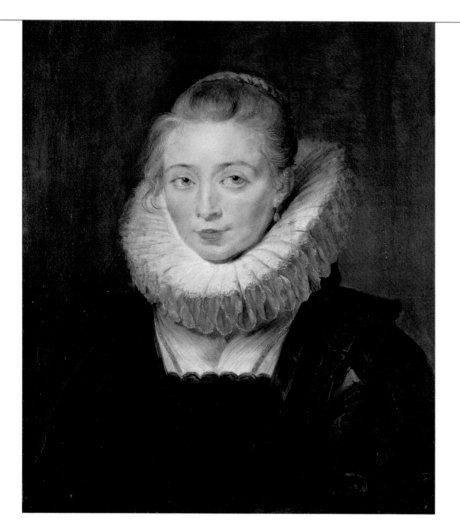

(Right) A painter, diplomat, courtier and businessman of extraordinary talent – this is how Rubens stands out for posterity. After studying in Antwerp, he left in 1600 for Italy, to serve briefly as Court Painter to Vincenzo Gonzaga, Duke of Mantua. During that time, Rubens began finding his style, copying works from antiquity, Renaissance masters such as Michelangelo and Titian, and contemporaries like Carracci and Caravaggio.

There is a symbolic meaning concealed in this decorative composition: the playful putti, symbolizing, in Rubens's words, 'happy times', are depicted decorating the niche of the Roman goddess of fertility with garlands of fruit and flowers. Rubens had a chance to see the statue of Ceres in the Borghese collection in Rome. By bringing the gifts of Nature to the goddess of antiquity they are paying tribute to the great art of the past.

Peter Paul Rubens
1577–1640
Flanders
Statue of Ceres, c.1615
Oil on panel, 90.3 × 65.5 cm
From the Carl Cobentzl collection, Brussels, 1768

Although there is no documentary evidence, the picture of this young and serious model is traditionally regarded as a posthumous, idealised, portrait of Rubens's elder daughter, Clara Serena, who died in 1623, at the age of twelve. Rubens has captured beautifully the characteristic features of youth: modesty, trustfulness, sincerity and purity. A technical virtuoso, he built up fine layers of paint to create an effect of translucence (an effect that is usually found only in watercolour), conveying the velvet soft texture of the skin and the moistness of the eyes. Using the most delicate of brushstrokes he has marked out each individual strand of hair. *Portrait of a Lady-in-Waiting to the Infanta Isabella* is unique amongst Rubens's work in that it is an outstanding psychological portrait, and one of the most inspired and poetic in seventeenth-century European art.

Peter Paul Rubens
1577–1640
Flanders
Portrait of a Lady-in-Waiting to the Infanta Isabella,
c.1623–25
Oil on panel, 64 × 48 cm
From the Antoine Crozat, Baron de Thiers collection, Paris, 1772

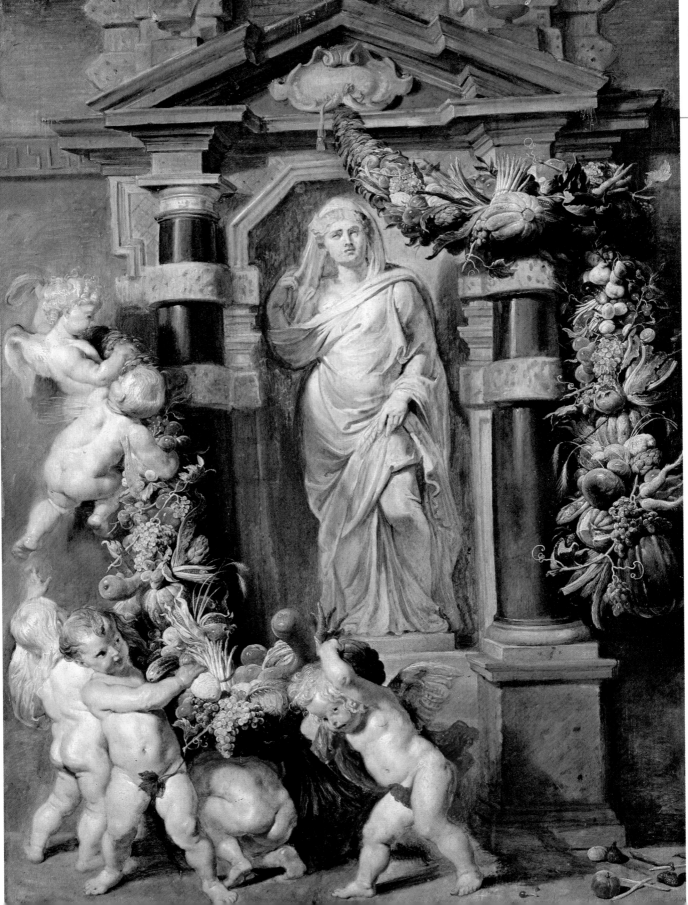

The Hermitage's collection of works by Rubens includes twenty-two paintings and nineteen sketches, covering all the different periods of the great master's creative works. Amongst his most famous canvases, and probably one of the museum's most precious paintings, is *Perseus and Andromeda*.

Ovid's *Metamorphosis* tells us how the Greek hero Perseus, son of Danae and Zeus, was flying over the sea when he saw Andromeda, daughter of the Ethiopian King Cepheus, chained to a rock and about to be sacrificed to the sea monster, Medusa. Perseus rescued Andromeda by beheading Medusa, instantly fell in love with the princess and then married her.

A similar composition is known to have adorned the façade of Rubens's house in Antwerp. It is likely that the myth was used as an excuse to compose a hymn to the power of love, youth, beauty and heroism. Descending from Olympia, the Goddess of Glory, bearing a palm, crowns Perseus with a laurel wreath. Andromeda, her features those of a blond and fair-skinned Flemish girl, drops her eyes modestly, shrinking slightly but not unwillingly before her saviour. This work shows Rubens at the height of his talent, both as a colourist and as a draughtsman. His technique is masterful: combining thick brushstrokes with fine layers of smooth paint, and using reflection and coloured shadows, he creates a sense of light emanating from the naked body of Andromeda, conveying the lightness of her silky hair, the cold shine of the metal and the glossy rump of the horse. Through gradations of tone and light, he creates an unusually rich and harmonious colour scheme.

Peter Paul Rubens
1577–1640
Flanders
Perseus and Andromeda, c.1622
Oil on canvas (transferred
from panel), 99.5 × 139 cm
From the Heinrich von Brühl
collection, Dresden, 1769

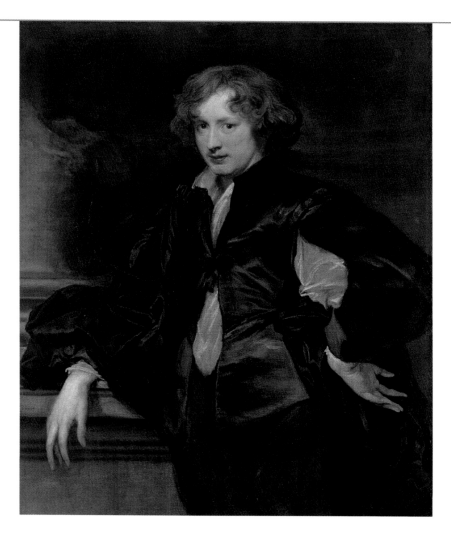

(Right) The seventh of twelve children born to a wealthy silk merchant in Belgium, Van Dyck started to paint very early. A precocious talent, he became an independent master around 1616 and went to work with Rubens in Antwerp. Soon, the young painter's own remarkable talents began to attract the attention of his contemporaries. In 1620 he was invited to work in London at the court of King James I, but after four months returned to Flanders, where he remained briefly before embarking on an extended trip to Italy where he achieved artistic maturity.

Back in Antwerp, in 1627, he was made Court Painter to the Infanta Isabella, Regent of the Netherlands. He was overloaded with commissions, wealthy and famous, yet, receiving an invitation from Charles I in 1632, he once more left Antwerp for London and this time stayed there almost continuously until his death. The nine years he spent in England were prolific and immensely successful: he almost exclusively painted portraits, each one invariably refined in its palette and imbued with the elegance that pervaded the court of Charles I. His work strongly influenced that of painters such as Reynolds and Gainsborough, and his finest portraits became models for English artists for centuries to come. Van Dyck was knighted in 1633. He is buried in St Paul's Cathedral, London, a distinction usually reserved for Britain's most illustrious subjects.

Anthony van Dyck
1599–1641
Flanders
Portrait of a Lady with a Tulip
(*Portrait of Jane Goodwin*), 1639
Oil on canvas, 132.5 × 106 cm
From the collection of
Sir Robert Walpole, Houghton
Hall, England, 1779

Anthony van Dyck
1599–1641
Flanders
Self-Portrait, 1622–23
Oil on canvas, 116.5 × 93.5 cm
From the Antoine Crozat,
Baron de Thiers collection,
Paris, 1772

The Hermitage owns twenty-four works by Van Dyck, a superb ensemble that offers an exhaustive overview of portraiture, a genre in which the Flemish master became world famous. One of the jewels of the collection, and, indeed, one of the finest portraits the artist ever painted, is his *Self-Portrait* of 1622–23, created not long after he returned from Italy.

Here Van Dyck tried to reveal the essence of creative personality, without resorting to the traditional attributes of the profession – brushes, easel, pallettes. He is depicted as young and attractive, with an almost feminine face and delicate hands, and carefully dressed in silk or satin shirts, bearing the same elongated elegance and aristocratic aloofness that is found in most of his sitters. The refinement of his manners and his artistic personality are clearly perceived through his posture and general appearance. Earlier but similar self-portraits are kept in the Alte Pinakothek, Munich, and the Metropolitan Museum, New York.

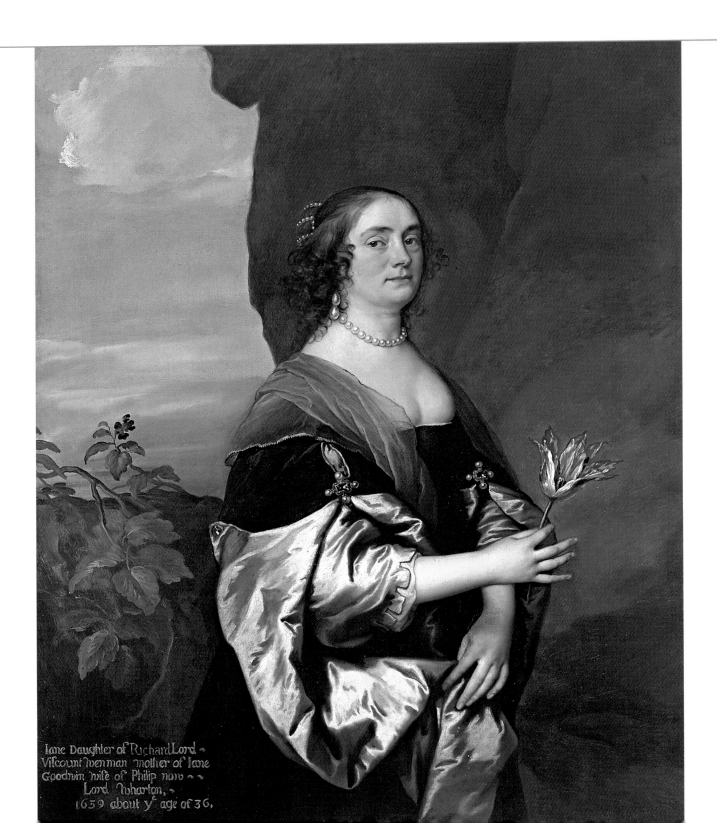

Iane Daughter of Richard Lord
Viſcount Iwenman mother of Iane
Goodwin wife of Philip now
Lord Wharton,
1639 about y.ᵉ age of 36.

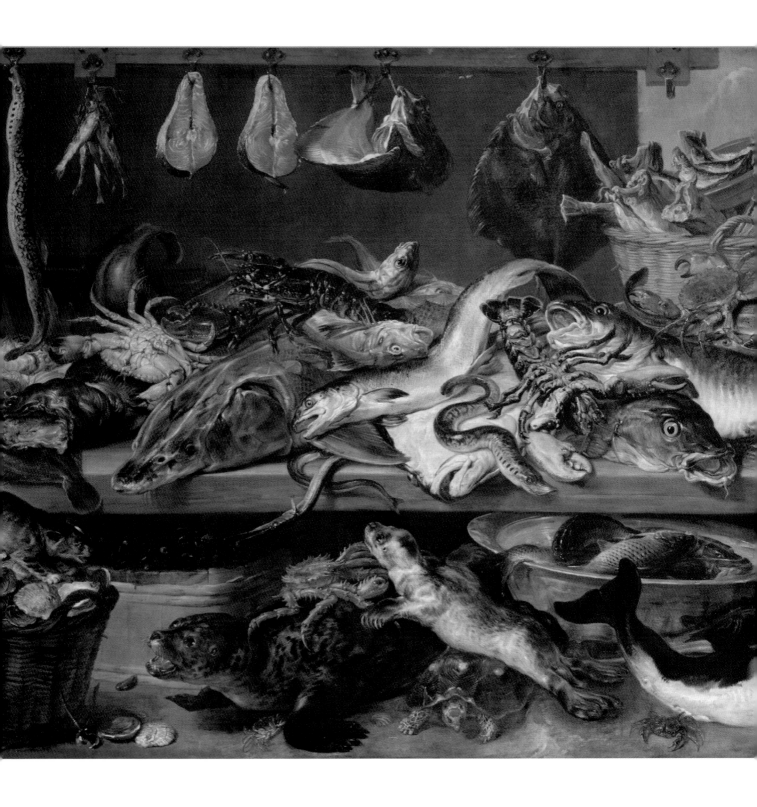

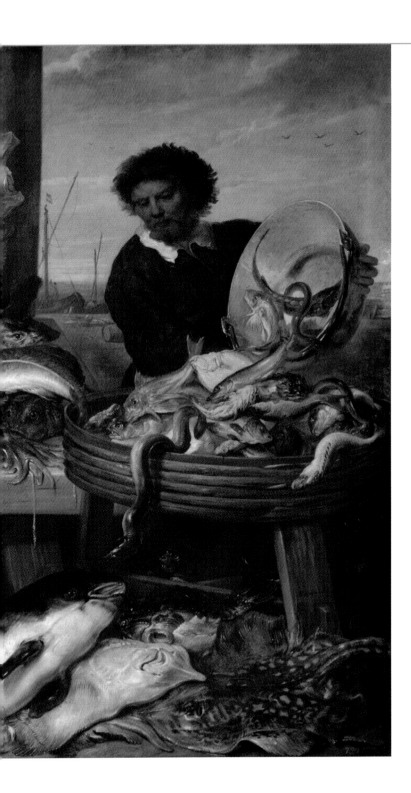

Frans Snyders was the undisputed master of Baroque still life and the founder of the Flemish animal still life. So outstanding was he that Rubens and others often contracted him to execute the still-life elements in their compositions.

Snyders specialised in large-scale market scenes, showing an amazing and rich variety of textures, colors and shapes. Many of his still-lifes and paintings of market stalls show an over-abundance of fruit, game, poultry, towering over counters and filling up baskets, creating a vision of wealth and prosperity, and a lavish image of Nature. *The Fishmonger's Shop* is no exception and overflows with food, in this case fish and shellfish, both alive and dead. There are three other large-scale canvases by Snyders on the same subject. All were painted between 1618 and 1621, probably conceived as a series. Indeed *The Fishmonger's Shop*, *The Greengrocer's Shop*, *The Game Shop* and *The Fruit Shop* hung together in the dining-hall of the palace of Bishop Antonius Triest in Bruges. These four canvases were amongst a collection of many remarkable paintings belonging to Sir Robert Walpole in the eighteenth century. Walpole's grandson, George, sold the entire collection to Catherine I in 1779.

Frans Snyders
1579–1657
Flanders
The Fishmonger's Shop, 1620s
Oil on canvas, 207 × 341 cm
From the collection of
Sir Robert Walpole,
Houghton Hall, 1779

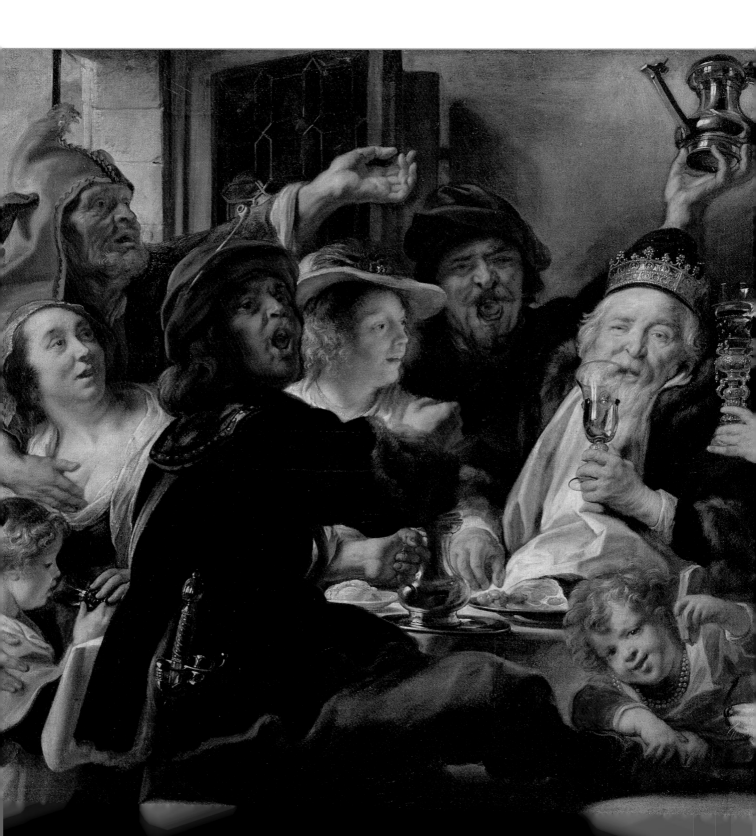

The subject of this picture is the *Feast of Epiphany* (or *Festival of the Three Kings*), a feast celebrated on Twelfth Night (or 6th January), a traditional meal at which the guests would be served a cake containing a bean. Whoever was lucky enough to find the bean in his slice of cake was proclaimed king for the night, or 'Bean King', and could choose a 'queen' and appoint a 'suite', that is, an adviser, a treasurer, a chamberlain, a musician, a cook and a jester. The participants were then obliged to submit to the royal pair in everything they asked or did, and if the Bean King lifted to his lips a glass of wine they had to shout 'The King drinks!' in chorus.

Jordaens chose to represent the bacchanalia at this precise moment, when the diners, having already drunk a few glasses, drink another goblet to the health of their king, a good-natured old man. The pleasure and hilarity of the moment is conveyed by the dynamic composition, the expressive gestures and animated facial features, and also through Jordaens's use of a warm, golden-brown palette, marking the artist as a follower of Rubens and one of the leading masters of the Flemish Baroque.

Jordaens's models were always taken from real life and more often than not he would have his relatives sit for him. For example, here Jordaens's father-in-law, Adam van Nort, sat for the Bean King, and the artist's daughter Elizabeth, for the Queen. The man behind them, holding a jug in his raised hand, who seems to be one of the most boisterous participants of the revelry, is endowed with the features of the artist himself. This particular subject was a favourite of Jordaens and his studio but the Hermitage possesses one of the earliest and best versions of his *The Bean King* – one that was entirely executed by Jordaens himself.

Jacob Jordaens
1593–1678
Flanders
The Bean King
(*The King Drinks*), *c.*1638
Oil on canvas (transferred from old canvas), 157 × 211 cm
From the Museum of the Academy of Arts, St Petersburg, 1922; formerly in the A. Bezborodko collection

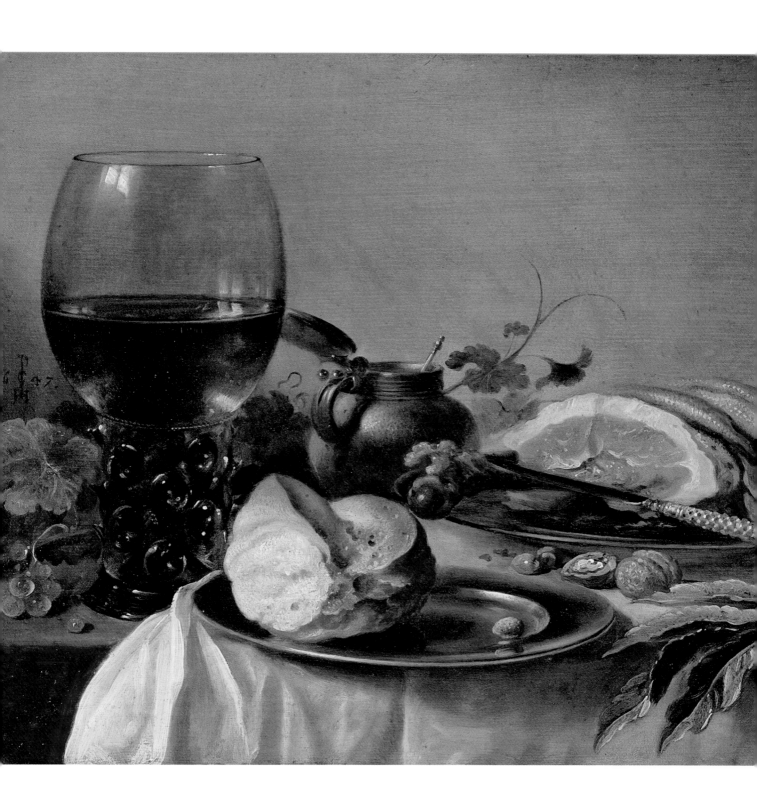

Pieter Claesz was born in Germany but married in Holland, where he remained for the rest of his life. He painted almost exclusively still lifes and, with Willem Claesz Heda, was one of the greatest exponents of a new genre, very popular in Dutch painting in the early seventeenth century: the 'breakfast piece'.

The everyday objects and ingredients depicted in these still lifes are almost always the same – some pewter, a glass, some bread, wine, fruit, fish or meat – and painted by Claesz with an exceptional realism, so as to make, as in this work, the texture of the ham, the soft skin of the peaches and the crust of the half-eaten bread almost tangible. Unlike many of his predecessors, for whom still life meant profusion, Claesz' compositions are modest, and the grouping of the objects simple and graceful, never overcrowding the table. The restrained colour range – subdued greys, browns and greens – reflects the Haarlem tradition of the so-called 'monochrome' still life.

Pieter Claesz
1597–1661
Holland
Breakfast with Ham, 1647
Oil on canvas, 40 × 61 cm
Acquired from
V. Kostromitinova, 1895

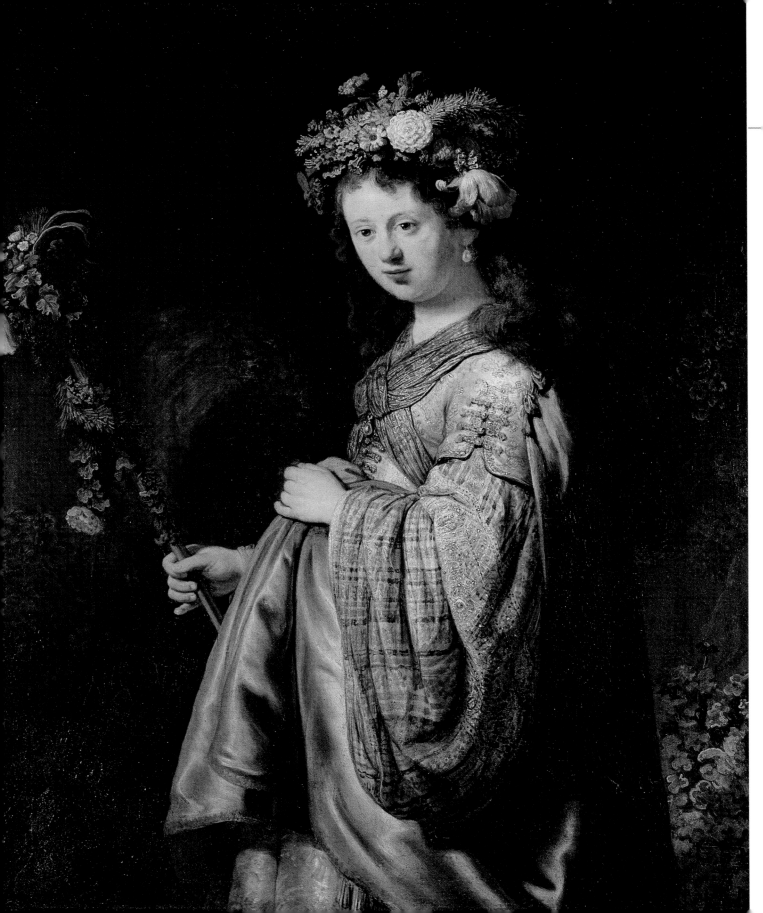

(Left) The Hermitage has over twenty works by Rembrandt van Rijn, one of the greatest artists in the history of art. The master's portraits and compositions on mythological or biblical subjects enable us to trace the various stages of his career, from his early canvases through to his last works. Among the early notable works by Rembrandt is *Flora*.

Rembrandt painted his first wife three times and this first portrait of her dates from the year of their marriage. Depicted as the goddess of spring and flowers, Saskia van Uylenborch (d. 1642) is dressed in rich oriental clothes, her face radiating a happiness that renders her otherwise ordinary features exceptionally beautiful. The rapturous love and admiration the artist felt for his wife is evident. The contrast between the young sitter's diffident pose and the sumptuousness of her richly embroidered clothes and accessories gives the image a special charm.

(Right) This is one of Rembrandt's finest compositions of the Holy Family. The traditional subject is treated as a scene from the everyday life amongst ordinary people: a modest room with a child's cradle, a carpenter (Joseph) at work in the background and a young mother with an open book next to a cradle where an infant sleeps. The theme of maternal love, so visible in the soft and tender looks Mary gives her child as she carefully tends to him, is treated in an intimate yet elevated manner. A source of mysterious light calls the viewer's attention to the angels descending from Heaven, and adds an element of mystery to an otherwise homely scene. Hendrickje Stoffels, who entered the Rembrandt household after the death of the artist's first wife to look after his son Titus, may have posed as Mary.

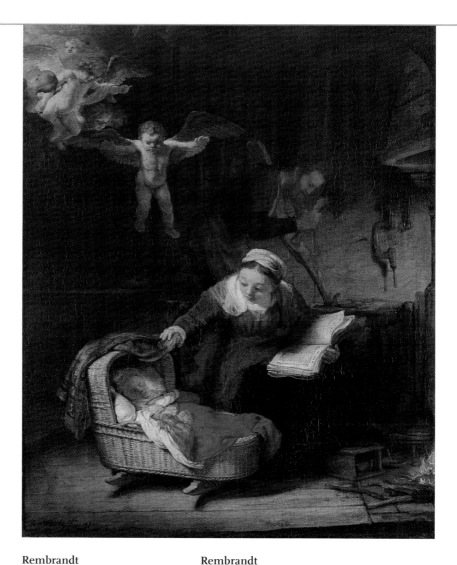

Rembrandt Harmensz van Rijn
1606–69
Holland
Flora, 1634
Oil on canvas, 125 × 101 cm
Acquired between 1770 and 1776

Rembrandt Harmensz van Rijn
1606–69
Holland
The Holy Family, 1645
Oil on canvas, 117 × 91 cm
From the Antoine Crozat, Baron de Thiers collection, Paris, 1772

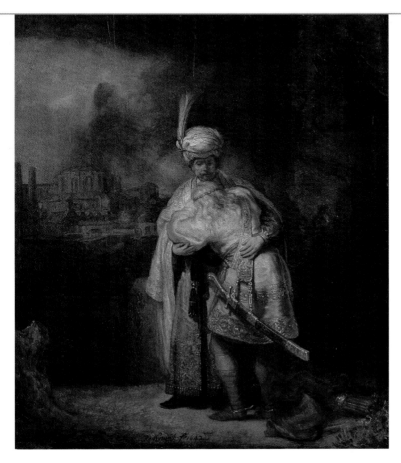

**Rembrandt
Harmensz van Rijn**
1606–69
Holland
*The Return of the Prodigal
Son, c.1666–69*
Oil on canvas, 262 × 205 cm
From the Duc d'Amesune
collection, 1766

**Rembrandt
Harmensz van Rijn**
1606–69
Holland
*David Parting from
Jonathan, 1642*
Oil on panel, 73 × 61.5 cm
From the collection of
Peter I in the Monplaisir
Palace, Peterhof, 1882

(Left) This is the first of Rembrandt's paintings to be brought to Russia by Peter I. The subject is taken from the First Book of Samuel (xx: 35–42). David was close friends with Jonathan, the son of King Saul. The king, jealous of their friendship and of David's great popularity at court, resolved to kill him, but Jonathan, learning of his father's intention, warned his friend of the danger, advising him to flee. David found shelter by the Ezel stone, where their last meeting took place.

Rembrandt has depicted the tragic moment of their parting before David's flight to the mountains. Many details mentioned in the Old Testament are included in this composition: the Ezel stone (which can be seen behind the figure of Jonathan), the rich garments, the girdle and sword given by the prince to David... The theme of love and sorrow that lies at the heart of the biblical story is captured with amazing force in this painting. It was a theme that appealed to Rembrandt, and several of his drawings from the early 1640s take as their subject the same Old Testament story.

(Right) This is one of the last works by the great Dutchman, and probably the most famous painting in the Hermitage collection. This time the subject comes from The Gospel According to Luke [XV: 20–24]: a son asks his father for his inheritance, leaves the parental home, then fritters away his entire wealth. Sick and destitute, he returns to his father's house. The old man is blinded by tears as he forgives his son, just as God forgives all those who repent. Rembrandt had already done a number of drawings on the same theme, but this painting treats the subject as a great tragedy elevated to a symbol of universal significance. There is an added dimension given that it was created in the last years of Rembrandt's life, when, after a lifetime of personal hardship, he was a sick, lonely and bankrupt man.

In *The Return of the Prodigal Son* the drama takes place in absolute silence and stillness. Complex emotions are expressed in the figure of the bent old man and his suffering, kneeling son: repentance and charity, boundless love and regret at the belated spiritual awakening. These images represent the summit of Rembrandt's psychological mastery.

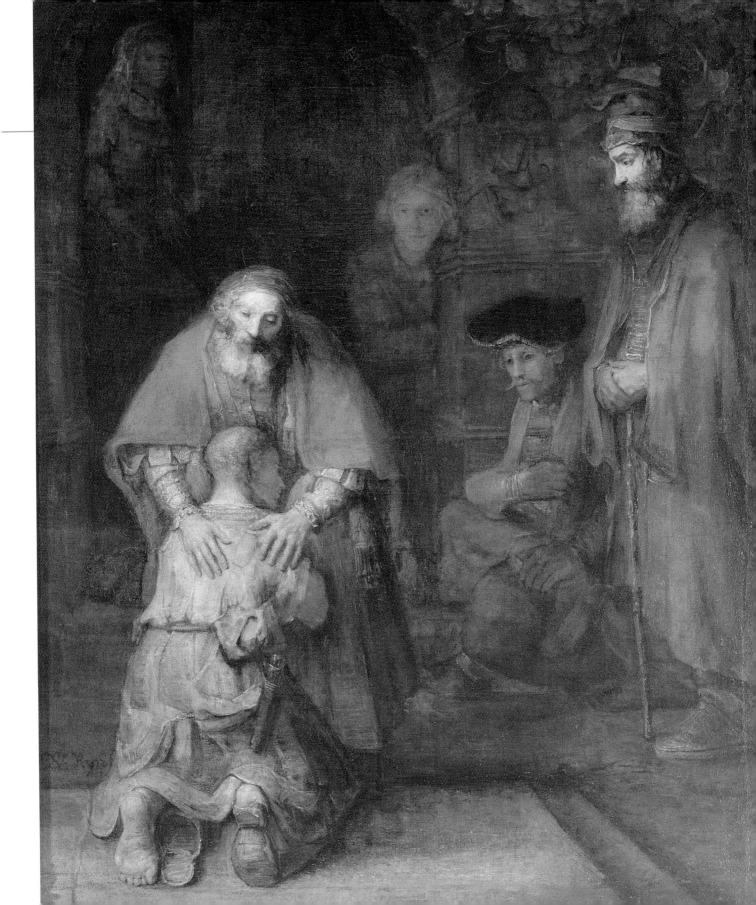

Ruisdael was one of the greatest and most influential Dutch artists of the seventeenth century. He was also one of the most versatile and prolific, painting virtually every type of landscape, producing more than seven hundred paintings and one hundred drawings. The Hermitage houses twelve canvases by Ruisdael, created at the different stages of the artist's career. They range from his early landscapes, rendered in a palette of greens and browns with great fidelity to nature, to his austere *Mountain Landscape* of the late period.

In *The Marsh*, Van Ruisdael's aspiration to create a heroic nature is fulfilled. The mighty trees are perceived both as an embodiment of eternity and as a part of nature changing in the inexorable course of time – an impression achieved by the juxtaposition of the fallen tree trunk with the slender young birch behind it. Great dramatic tension is concealed in the apparent tranquillity of this lonely scene. The powerful trunks and branches stretching convulsively towards the sky form a dense canopy over the dark, dormant, waters from which a young duck seems desparate to escape, and the solitary figure lost in the background seems tiny in comparison.

Jacob Isaaksz van Ruisdael
*c.*1628–82
Holland
The Marsh, *c.*1665–9
Oil on canvas, 72.5 × 99 cm
Acquired between 1763
and 1774

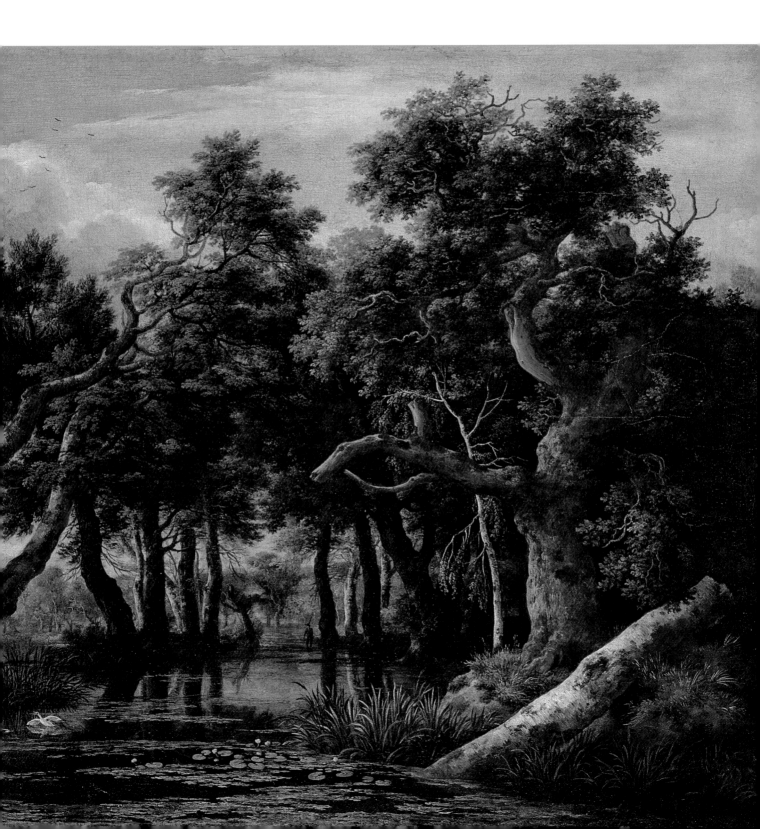

Jan Steen
c.1625–79
Holland
*The Idlers, c.*1660
Oil on canvas, 39 × 30 cm
From the Johann
Gotzkowsky collection,
Berlin, 1764

Frans Hals
c.1581–1666
Holland
*Portrait of a Young
Man with a Glove, c.*1650
Oil on canvas,
80 × 66.5 cm
From the Johann
Gotzkowski collection,
Berlin, 1764

These two paintings were amongst the first works of art to be acquired by the Hermitage. They belonged to the collection of a rich Berlin merchant, Johann Gotzkowski, that was given up to clear his debt to the Russian Treasury in 1764. Frederick II, who owned a wonderful collection of contemporary French paintings, had ordered Gotzkowski, one of his agents, to purchase works by old masters. The zealous merchant put together a large collection, but Frederick, bankrupt by the Seven Years' War, refused to make the purchase. Gotzkowski was forced to look around for alternative buyers and he offered the collection to Russia. Catherine II saw there the opportunity to humiliate Frederick by proving that the Russian State Treasury, despite losses which were no less than those of Prussia, could still afford to make such an expensive acquisition. The quality of the 225 paintings acquired by Gotzkowski was uneven, but among them were at least two masterpieces: Jan Steen's *The Idlers* and Frans Hals's *Portrait of a Young Man.*

(Left) In his works, the illustrious Dutch genre painter Jan Steen combined the skills of a fine storyteller with those of a brilliant painter. The scene mingles grotesque and gentle humour, a trait that is typical of works by Steen; the woman, having drunk too much, her head on her arm resting on the table, is painted with characteristic satirical acerbity; the smoker, her husband, is clearly enjoying the situation and seems to be gently mocking his wife. *The Idlers* are Jan Steen himself and his wife Marguerite. The masterful composition, the extraordinarily accurate characterization and lively use of colour make this work one of the artist's greatest achievements.

(Right) Franz Hals had a great gift for portraiture. Painting directly from his model and working extremely fast, without preliminary sketches, he achieved an immediacy and brilliance in his portraits that was previously unknown in the Netherlands. He was especially good at depicting the sitters in a simple pose (but almost always seated at an angle), and catching their fleeting expressions. His innovative, vivacious portrayal of pink-cheeked, vigorous, self-confident fellow contemporaries grew to be a symbol of the cultural life of the young Dutch Republic, while his informal group portraits became very fashionable with Manet and other Impressionists at the end of the nineteenth century. The bold, animated brushstrokes are typical of the painter's late work. If, through the 1620s, Hals's pictures were joyous in mood, during the 1630s his style became increasingly sober, as seen here, in *Portrait of a Young Man with a Glove.* The sitter remains, to this day, unidentified.

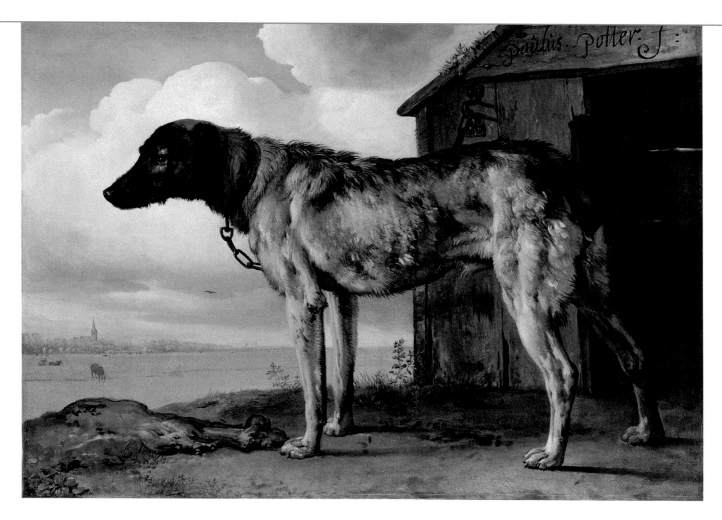

Paulus Potter was one of the most brilliant Dutch animal painters, attuned
to nature in an extraordinary way. He produced numerous strikingly accurate
'portraits' of dogs, cows, horses and bulls, in which he revealed, with great skill
and sensitivity, the most essential traits of their character and behaviour.

In *Watchdog* Paulus created an expressive, profoundly individual image of
an animal. The low, flat horizon underscores the plain character of the Dutch
scenery. This painting may have been commissioned by Dirk Tulp, whose father,
Professor Nicolas Tulp, had travelled to Russia in 1648 and possibly brought the
dog back with him. Nicolas Tulp, who had spotted the genius of a young
Rembrandt van Rijn twenty years earlier, was so impressed by Potter's paintings
that he persuaded him to move to Amsterdam in 1652, whereupon he became
the artist's mentor. Potter, however, died only two years later the age of
twenty-eight.

Paulus Potter
1625–54
Holland
Watchdog, 1653–4
Oil on canvas,
96.5 × 132 cm
From the Empress
Joséphine collection,
Malmaison, 1806;
acquired in 1814

Pieter de Hooch is one the the best-known
and best-loved Dutch genre painters, famous
for his interior scenes and use of light. He
devoted his work to the glorification of the
everyday life of his native Delft, finding
poetry in the most simple scenes. He tended
to focus on the portrayal of diffused sunlight
flitering through an interior, the luminosity
and freshness of backyards and quiet rooms.
The use of geometric patterns on tiled floors,
such as here in *Mistress and Maid*, create the
illusion of a spacious and airy courtyard.
This simple scene, reproducing the dialogue
between a mistress and her maid, has
become, in the hands of De Hooch, a hymn
to the comfortable and peaceful domestic
life of a Dutch house. The painting's
distinctive composition, the clear, cold
colouring, the view through the gates that
resembles Amsterdam more than Delft
– all concur to indicate that this picture
was painted after the artist had moved
to Amsterdam in the 1660s.

Pieter De Hooch
1629–after 1684
Holland
Mistress and Maid, after 1660
Oil on canvas, 53 × 42 cm
Acquired from the art
dealer Lafontaine,
Paris, 1850

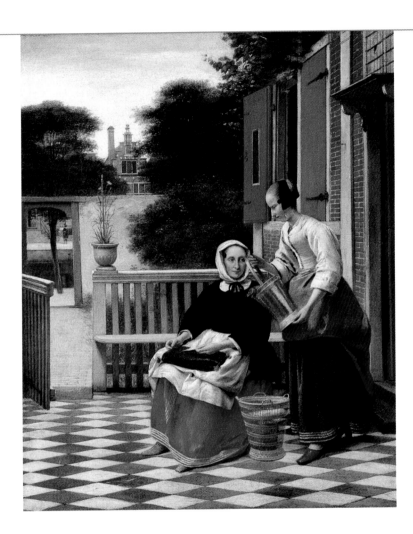

OTHER WORKS

German, Spanish and English schools

El Greco
1541–1614
Spain
St Peter and St Paul,
1587–92 (detail)

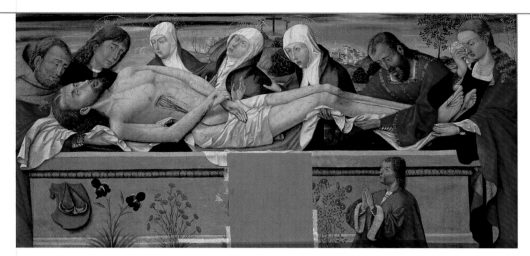

Domenikos Theotokopoulos (El Greco)
1541–1614
Spain
St Peter and St Paul,
1587–92
Oil on canvas,
121 × 105 cm
From the Peter Durnovo collection,
St Petersburg, 1911

This late fifteenth-century work is a tribute to International Gothic, a style then popular in Spain. The central scene is treated in traditional manner, set against a landscape background incorporating elements of architecture, with exquisite flowers growing by the sarcophagus, and a portrait of the donor. The cross from which Christ's body has just been taken down is visible in the background; John the Evangelist, Joseph of Arimathea and Nicodemus have wrapped Jesus's body in clean sheets and, their eyes expressing deep sadness, gently lay it into the newly prepared sepulchre. The three Marys stand by the tomb, each expressing her grief in a different way: the repentant sinner, Mary Magdalene, looks upwards in distress, Mary Salome, her gaze fixed on Christ's face, holds His legs to place them gently in the tomb; the Virgin wipes tears from her eyes. Christ's body is carefully turned so that we may see the wound in His side and the blood. The donor kneels at the altar and is shown, too, feeling grief and wonder – feelings the artist clearly wanted those who would kneel in front of the painting to feel. A similar picture exists in the parish church of Manzanillo, Valladolid province.

Unknown fifteenth-century artist
Spain; Castilian school
Entombment, 1490s
Tempera and oil on panel, 94 × 182 cm
From the All-Union Society Antiquariat, St Petersburg, 1933

(Right) Peter and Paul, the two principal apostles of the Christian Church are shown here discussing the Christian doctrine. The New Testament tells how the two men met in Antioch and how, on that occasion, two opinions clashed as Peter wanted to confine Christianity to the limits of Judaism and Paul wanted to interpret it as a universal religion – Peter symbolising the original Jewish element and Paul the gentile principle that triumphed. The faces of both men display the same spiritual expression, with their ascetic looks and hollow cheeks, but El Greco has, at the same time, brilliantly portrayed the clash of the two characters: Paul, on the right, in a fiery red coat, his head proud and held high, is a man of conviction (it is possible that the artist modelled the saint on himself), while Peter, placed a little to the side, holding a key, with his head tilted slightly, gives Paul a soft and forgiving look and seems ready to compromise.

Born on the Greek island of Crete, Domenikos Theotokopoulos reputedly studied with Titian in Venice, moved to Rome in 1570 and in 1577 left for Spain, where he spent the rest of his career. There he became known as El Greco (The Greek). Even during his lifetime, he was acclaimed for his religious subjects painted in a passionate and strikingly individual style. The tendencies that gradually developed in the works of his mature period are already visible in *St Peter and St Paul*: the elongated proportions of the figures, the enhanced contrasts in lighting, the intensity of colour and the free brushwork.

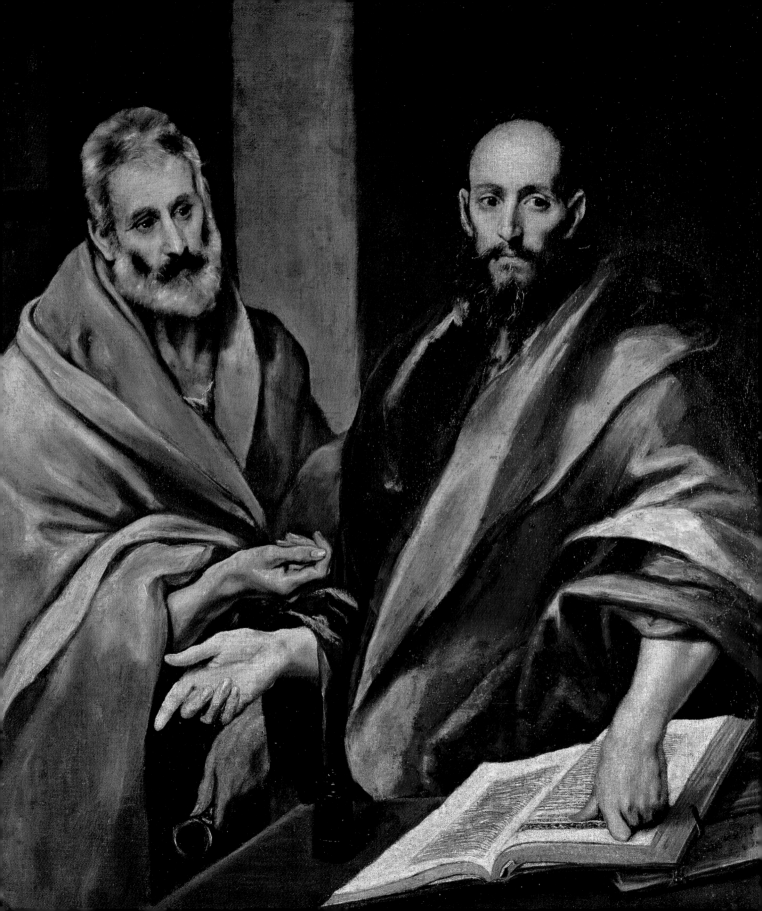

St Jerome was one of the four Fathers of the Church in Rome (the other three being Ambrose, Augustine and Gregory). Jerome translated the Bible into Latin and spent many years as a solitary hermit in the desert. His cult enjoyed great popularity in the sixteenth and seventeenth centuries, especially in Spain. He is shown here with all the attributes of his character – a scroll, some books, and, on the left, a lion – and depicted as the penitent in the desert listening to the sound of the heavenly trumpet. Ribera obviously sought to convey the horror that struck the hermit when he heard the trumpet sounding the Last Judgement.

Although he spent most of his career in Italy, where he became known as 'Lo Spagnoletto', the Valencia-born painter José de Ribera is one of the key figures of the Golden Age of Spanish painting, and was particularly good at showing martyrdom through his use of powerful images of resigned suffering. As a young man Ribera moved to Italy – first to Rome, and then to Naples, where he had a succession of Spanish viceroys as patrons. His most influential master was undoubtedly Caravaggio, whose work he would have seen both in Rome and Naples. Caravaggio's influence is clearly visible in *The Vision of St Jerome*: Ribera's use of sharp chiaroscuro and his heightened sense of drama are purely Caravaggiesque. To these, however, he adds two qualities: Spanish realism and his own brilliant technique.

José (Jusepe) de Ribera
(Lo Spagnoletto)
1591–1652
Spain
The Vision of St Jerome, 1626
Oil on canvas, 185 × 133 cm
Acquired from Manuel Godoy
in Paris, 1831

Francisco de Zurbarán was a brilliant master of the still life and portrait but he is renowned mostly as a painter of sober and austere religious images, which he painted for churches and monasteries across the south of Spain. Tenebrism and chiaroscuro predominated in his early works – he was called the Spanish Caravaggio, but then tenebrous backgrounds gave way to landscapes, a softer, more lyrical expression and a richer palette started to appear on his canvases. *St Lawrence* is one of these later works and was painted during Zurbarán's most successful and productive period.

St Lawrence, roasted to death on a grid by the Romans in AD258, was a native of Aragon, which accounts for his popularity in Spain. He is shown here dressed in a deacon's garb and holding a gridiron, the instrument of his execution. Zurbáran was especially famous for his masterful renditions of white, finely elaborated by means of light-and-shade contrasts. The monumental figure looks very much like a painted sulpture.

Francisco de Zurbarán
y Salazar
1598–1664
Spain
St Lawrence, 1636
Oil on canvas, 292 × 225 cm
Acquired at the sale of the
Marshal Soult collection,
Paris, 1852

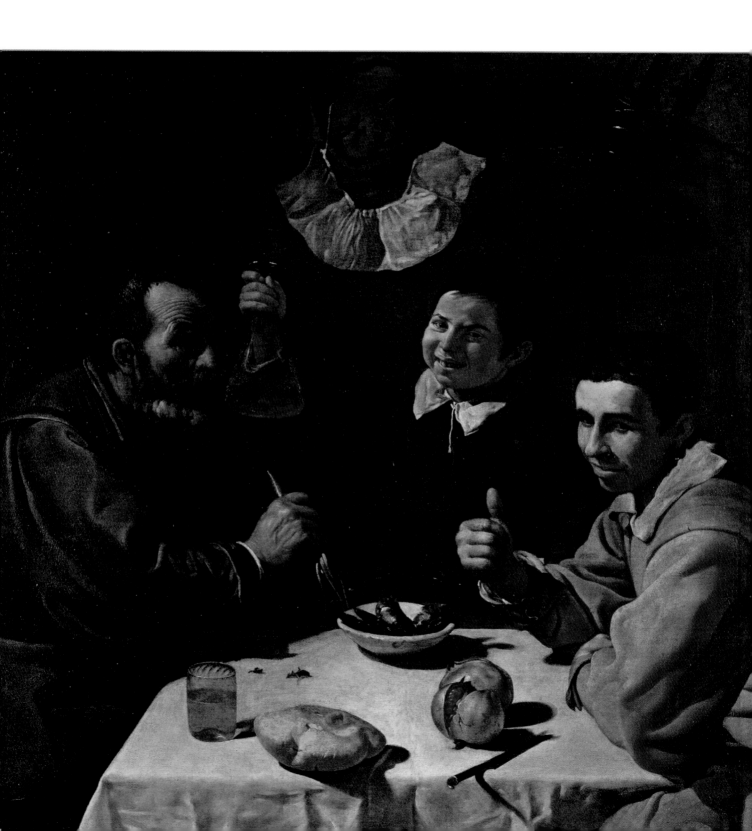

(Left) When this painting first came to the Hermitage it was regarded as the work of an unknown Flemish artist, and it was only in 1895 that it was attributed, beyond a shadow of a doubt, to Diego Velázquez.

Velázquez was the central figure in the Golden Age of Spanish painting and ranks among the greatest masters of seventeenth-century Europe. *Luncheon* belongs to the early years of Velázquez's career and reveals his interest in genre painting, a style that was just beginning to come into fashion in Spain – pictures like the one reproduced here were called *bodegónes*, or tavern scenes. It also shows the artist's strong liking for Caravaggesque features: a gathering of people at a table as a subject, and the use of sharp chiaroscuro. Like Caravaggio, Velázquez practised realism and was concerned with the effect of light emanating from a single source, bringing out the volumes of the objects and figures. This scene is vivid and spontaneous – the three men were clearly painted from life, and the same models appear in other works by the painter. Arranging three or four objects on the table, set slightly apart from each other, was typical in Spanish still-life painting of the time. The young man on the right is probably a self-portrait of Velázquez himself.

(Right) In 1623, Velázquez's life took an important turn when he was named Court Painter or *pintor del rey*, to Philip IV, king of Spain, with whom his life and work would be closely linked until his the artist's death. At court Velázquez produced large narrative pictures but, as his official position required, mostly painted portraits (today considered to be some of the best official portraits ever produced). Moreover, he redefined traditional portraiture, with its standard poses and attitudes, by concentrating on the psychology of his sitters and depicting them with painterly brilliance and rich colour.

Don Gaspar de Guzman, Count de Olivares and Duke de San Lucar (1587–1645), was an omnipotent minister at the court of Philip IV and it had been with his assistance that Velázquez had left his native city of Seville for the kingdom's capital in 1623. The artist painted many portraits of Olivares: the one housed in the Hermitage dates from the late period of his career. In this work, Velázquez reveals a complex personality: behind the smile, tranquillity and apparent mildness one can sense sharp intelligence and an iron will. The range of colours is restrained, almost austere. The contrast of the intense black of the costume and the white of the collar against the delicate olive-coloured background and the sharp illumination of the face, give an almost tangible sensation of the count's personality.

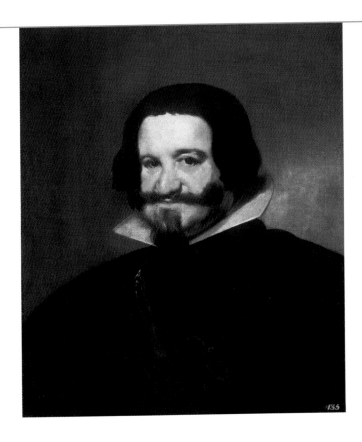

Diego Rodriguez de Silva y Velázquez
1599–1660
Spain
*Luncheon, c.*1617
Oil on canvas, 108.5 × 102 cm
Acquired between 1764 and 1774

Diego Rodriguez de Silva y Velázquez
1599–1660
Spain
*Portrait of Count Olivares, c.*1640
Oil on canvas, 67 × 54.4 cm
From the William Coesvelt collection, Amsterdam, 1814

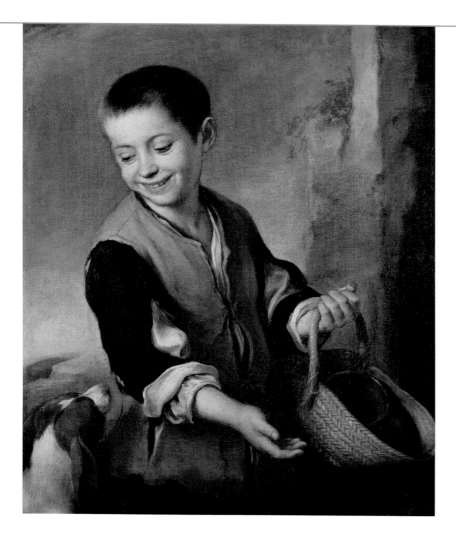

Bartolomé Estebán Murillo
1617–82
Spain
Boy with a Dog, 1655–60
Oil on canvas, 74 × 60 cm
From the Duke de Choiseul
collection, Paris, 1772

(Left) There are thirteen paintings by Murillo in the Hermitage, ranging from monumental canvases such as *The Rest on the Flight into Egypt* to the contrasting, more intimate genre painting such as *Boy with a Dog*. These pictures provide an unusually clear overview of the artist's career, whose work marked the culmination of seventeenth-century Spanish art.

Murillo was born in Seville and spent his entire, rather uneventful, life in the southern Spanish city of Seville. In 1645, he received what is thought to be his first commission, from one of the city's many local religious institutions. As was the case with all Spanish painters of his time who weren't court painters, and also because he was an extremely devout man himself, Murillo devoted himself mainly to religious subjects and genre scenes. By 1650 his reputation was made and he was working non-stop for churches and monasteries, later also taking on work for private individuals such as Dutch and Flemish merchants. The market for his pictures was so large and lucrative that the king refused to allow their export from the country. Murillo himself never left Spain.

Many of the Murillo's genre scenes were of Seville's lower classes and he was an unsurpassed master of children's portraits where he showed, as here with *Boy with a Dog*, obvious empathy and affection for his subjects. This scene, with its lively dialogue between the boy and the animal, caught the fancy of Edouard Manet, who used the subject in one of his paintings and several of his engravings.

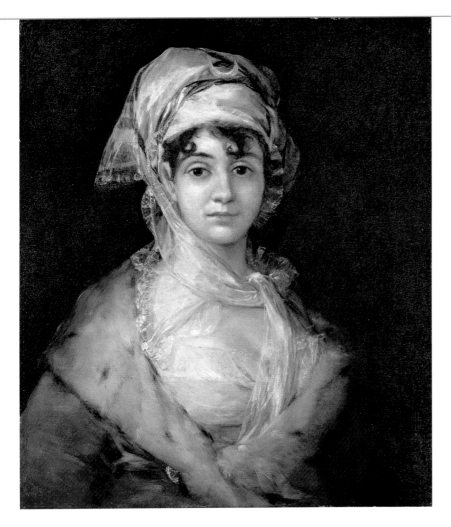

**Francisco José de Goya
y Lucientes**
1746–1828
Spain
Portrait of Antonia Zárate,
1810–11
Oil on canvas, 71 × 58 cm
Bought and presented by
Armand Hammer in 1972

From the 1780s onwards, Francisco de Goya was the most fashionable portrait painter of Madrid society and, consequently, left a remarkable gallery of Spanish society at the time. Following in Velázquez's footsteps, he became *pintor del rey* to Charles IV in 1789 and, in 1799, became First Court Painter, the highest position available to an artist at the Madrid court.

This portrait, the only work by Goya in the Hermitage, was presented to the museum in 1972 by American businessman Armand Hammer. It represents Antonia Zárate, an actress, friend and admirer of Goya. He painted her twice, shortly before she died of tuberculosis at the age of 36 – the other portrait of her is in the National Gallery of Ireland, Dublin, and shows her seated on a sofa. This work, where she is presented half-length, looking straight at the beholder with sadness and dignity, is permeated with profound emotion.

In the early years of the nineteenth century, Goya's style of portraiture changed: he eliminated unessential details in the costumes, and gradually abandoned the idea of a setting in favour of a neutral, often dark, background, against which the sitter becomes the obvious and only important element, thereby beginning to create more intimate, psychologically revealing portraits in which the subjects are depicted simply and directly. This type of portrait introduced a new trend in nineteenth-century European painting, and was amongst the works that foreshadowed the Romantic movement.

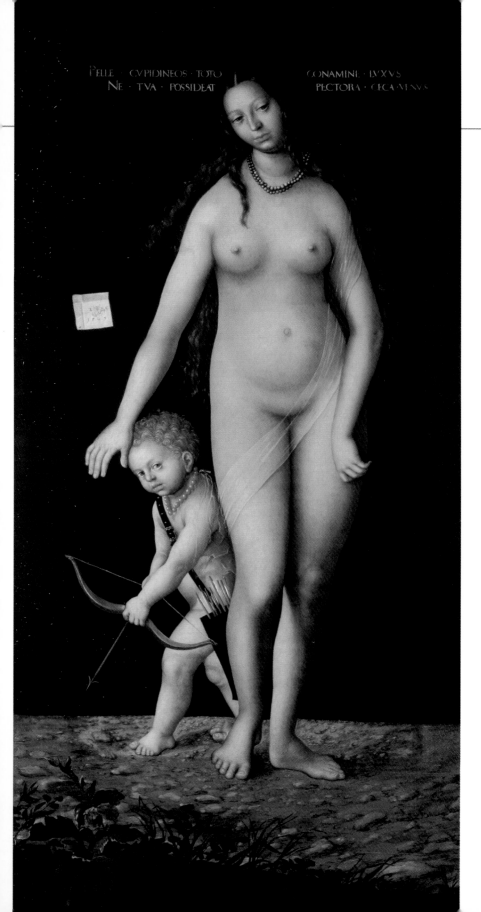

PELLE · CVPIDINEOS · TOTO · CONAMINE · LVXVS
NE · TVA · POSSIDEAT · PECTORA · CECA · VENVS

(Left) Little is known of this artist's early life. To all appearances, his real name was Lucas Mahler. He began to call himself 'Cranach' (after his birthplace Kronach) during his stay in Vienna in 1502, and under this name has become known as the leading figure of the German Renaissance. In 1505, at the invitation of Frederick the Wise, Elector of Saxony, Cranach moved to Wittenberg and became Court Painter, a position he maintained (under various prince electors) to the end of his life. He also became a close friend of Martin Luther, who taught at the University of Wittenberg.

It is said that Cranach was the inventor of the full-length portrait, and from 1505 he painted many female figures for the court. In many instances these figures were depicted as solitary beings, alone in a sparse landscape and wearing little more than a transparent veil, jewellery and, occasionally, a hat. *Venus and Cupid* is Cranach's first painting to be based on a subject taken from classical mythology – it is also the earliest North European work to depict the goddess of love and beauty completely nude (previously only Eve had been shown naked). As if to balance his own enthusiasm for the Italian Renaissance archetypal feminine beauty, Cranach inserts a Latin inscription, warning of the temptation of the flesh:

> 'With all your strength ward off Cupid's love of voluptuousness,
> For else Venus will take over your blinded soul.'

Lucas Cranach the Elder
1472–1553
Germany
Venus and Cupid, 1509
Oil on canvas (transferred from panel), 213 × 102 cm
From the Heinrich von Brühl collection, Dresden, 1769

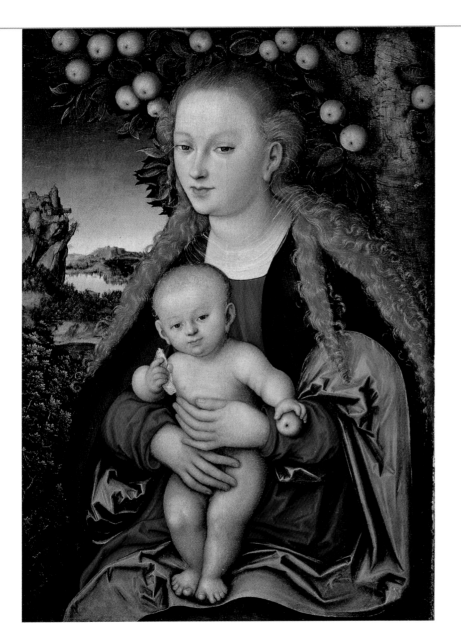

The *Virgin and Child under an Apple Tree* is the Hermitage's most outstanding painting from Cranach's mature period. The innermost meaning of the painting lies in the Christian dogmas of Sin and the Fall of Man and the Salvation of the human race: the young Christ holds in his hand an apple and a crust of bread, symbolising atonement for Man's original sin at the cost of his own earthly life. The Virgin is here to atone for the sin of the mother of the human race (i.e. Eve), and is a development of a 'Protestant' type of Virgin, the embodiment of the True Church on earth. But while he painted a complex picture that is full of meaning, Cranach also endowed it with it beauty and majesty, depicting the Virgin as the true queen of the earth set against a superb background. The tranquil panorama reflected on the smooth surface of the water, and the chain of blue hills on the horizon are a testimony of Cranach's excellent draughtmanship and his deeply poetic sensitivity to landscape. The use of strong colours – the rich and beautiful combination of red and golden-yellow with emerald green and cold pale blue – is also typical of the master's paintings.

Lucas Cranach the Elder
1472–1553
Germany
*Virgin and Child under an Apple Tree, c.*1530
Oil on canvas (transferred from panel), 87 × 59 cm
Acquired in 1851

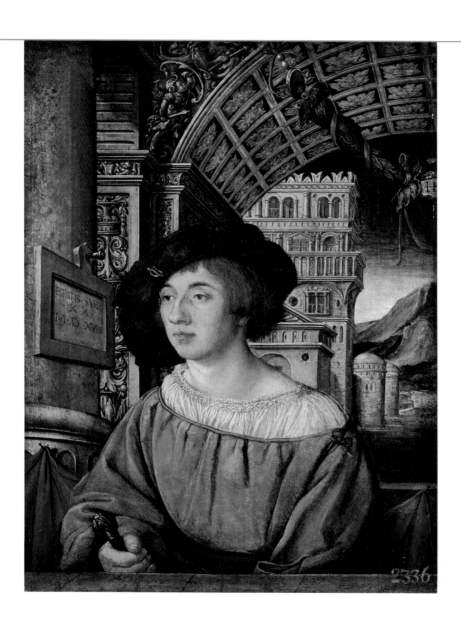

Portraits by Ambrosius Holbein are a great rarity, as the artist died very young. This one, housed in the museum since the mid-eighteenth century, was originally ascribed to Hans Holbein the Younger, one of the most famous German portrait painters and Ambrosius's younger brother. Up until now scholars have failed to identify the sitter, who wears a beret with the initials 'F G' embroidered on it. On the column on the left is a cartouche bearing an inscription: 'At the age of twenty, 1518,' which almost certainly relates to the model. The prominent figure in the foreground of the painting, the sense of poise and dignity, and the classical architecture in the background seem to have all been used for a single purpose – the celebration of man – and echo the ideas of humanism that were fashionable in Germany at the time.

Ambrosius Holbein
*c.*1495–*c.*1520
Germany
Portrait of a Young Man, 1518
Tempera and oil on panel,
44 × 32.5 cm
Acquired between 1774
and 1783

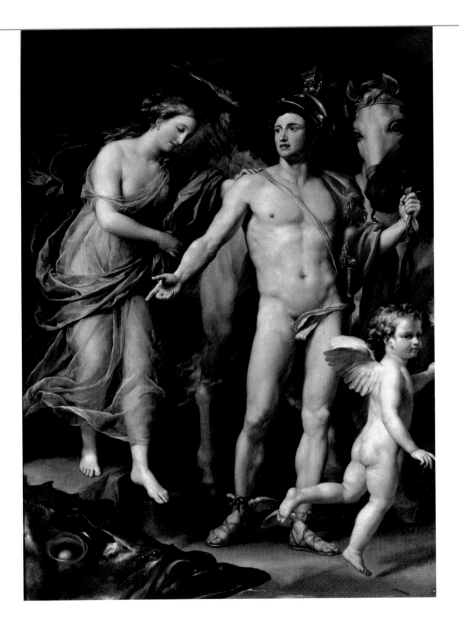

Mengs's work was highly valued by Catherine II, who also relied on the painter's taste and erudition, virtually making him her artistic agent.

Perseus and Andromeda exemplifies Mengs's desire to find inspiration in the classical heritage and traditions. The ordered nature of the unfussy composition, the classically perfect drawing, the skilful sculptural modelling of the figures and the majestic rhetorical gesture of the central figure all indicate that the work was composed according to the strict canons of Neoclassicism, of which Mengs was a both a master and devout follower.

The subject of this painting was taken from Ovid's *Metamorphosis* and the concept prompted by an antique cameo (now also in the Hermitage) that was owned by Mengs's wife. The figure of Perseus was modelled on the statue of the Apollo Belvedere and that of Andromeda on an antique relief from the Villa Doria Pamphilj in Rome. The work was commissioned by an Englishman of the name of Sir Watkins William Wynn. In 1778 the ship carrying the painting to England was captured by French pirates who then sold the cargo in the Spanish port of Cadiz. There the painting was bought by the French naval minister, de Sartinue, who sent it to Versailles. It is probable that it was acquired in 1779 on the instruction of Catherine II.

Anton Raphael Mengs
1728–79
Germany
Perseus and Andromeda, 1774–77
Oil on canvas, 227 × 153.5 cm
Acquired between 1777
and 1783

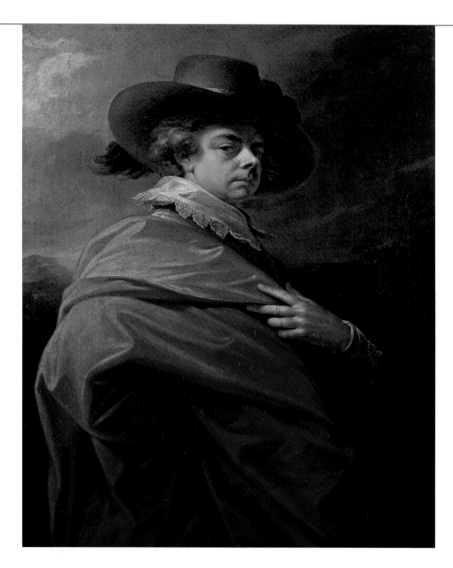

(Left) Heinrich Füger was a representative of the eighteenth-century Austrian school, a Neoclassical artist and the Director of the Vienna Academy of Arts. Nikolai Borisovich Yusupov, a Russian statesman, collector and bibliophile, was at one time at the head of the Imperial Hermitage. He was sent to Italy on a diplomatic mission and, besides his main occupation, spent some time purchasing works of art for Caherine II. He presumably commissioned this portrait in 1783, when he stayed in Rome.

(Right) This portrait was painted for the '1812 War Gallery' of the Hermitage, a gallery created in 1826 by Carlo Rossi in commemoration of Russian victories in the Napoleonic Wars. On the Gallery's walls hang 332 portraits of the generals who were heroes of the Patriotic War of 1812 and European campaigns of 1813–14. At the two short ends of the gallery hang the two equestrian portraits by Franz Krüger: one of the Emperor Alexander I, the other of his ally in the war with Napoleon, Frederick William III of Prussia.

 In the portrait shown right, Alexander I is shown astride his horse Eclipse, with the city of Paris in the background. This horse, presented by Napoleon in Erfurt in 1809, carried Alexander I into the French capital after the crushing defeat of Napoleon's Grande Armée in 1814.

Heinrich Friedrich Füger
1751–1818
Austria
Portrait of Prince Nikolai Yusupov, 1783
Oil on canvas, 112 × 87 cm
From the Yusupov Palace Museum, St Petersburg, 1925

Franz Krüger
1797–1857
Germany
Portrait of Emperor
Alexander I on Horseback, 1837
Oil on canvas,
484 × 344 cm

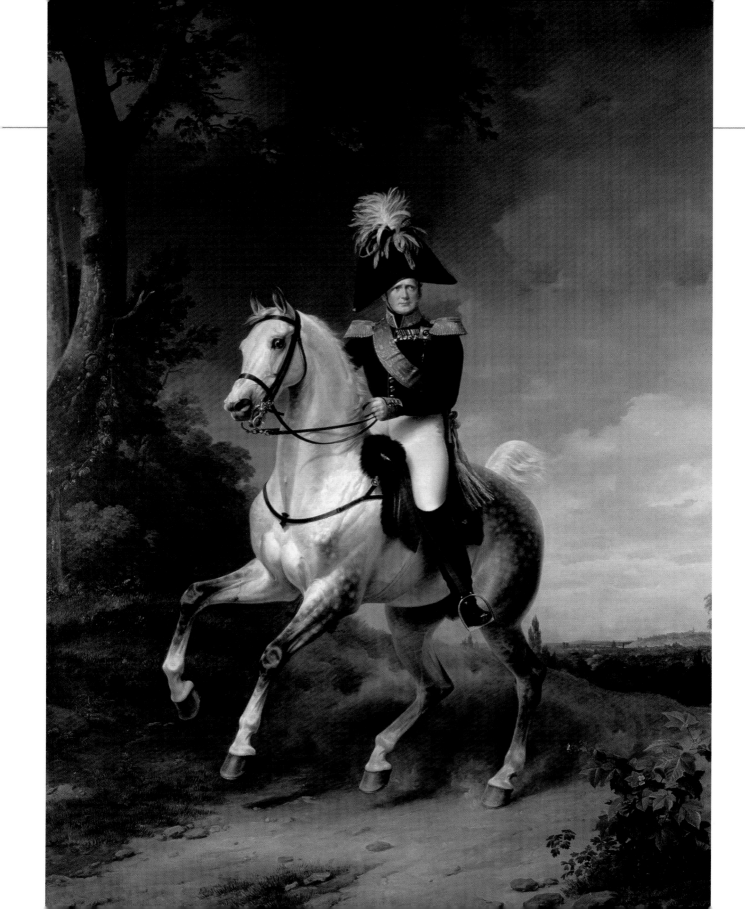

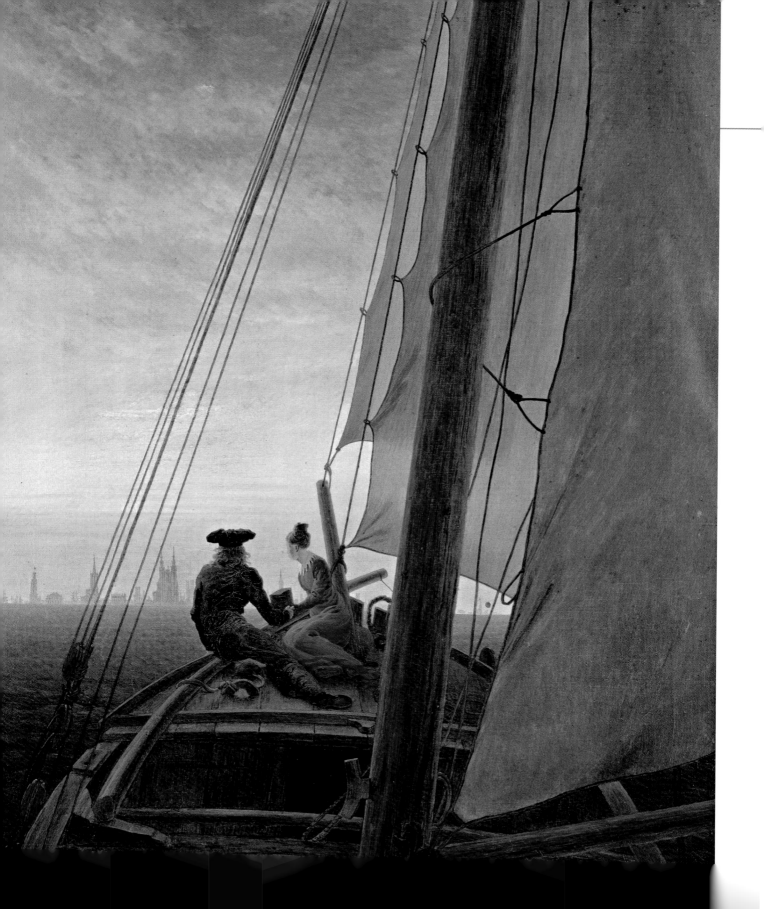

(Right) Friedrich's art, though evocative and highly imaginative, was based on a serious and meticulous study of nature. On his many sketching tours he would record everything he saw with an almost documentary precision. His relationship with nature was deeply spiritual and Christian-based and he loaded his paintings with symbolism – ruined Gothic churches, cemeteries, desolate landscapes, silent figures in vast spaces, forests – capturing the vast infinity both of nature itself and of man's spiritual world.

The Dreamer is a perfect example of a picture composed according to Romantic principles: a lonely figure meditating, set amidst the ruins of a Gothic monastery, lit only by the melancholic rays of the setting sun – all were characteristic elements of the Romantic landscape genre in general and its brilliant exponent Caspar David Friedrich in particular.

(Left) Caspar David Friedrich was the most purely Romantic of German landscape painters. Of the nine works by him in the Hermitage, this one is rare in that it is a representation of a real event. The work was executed shortly after the artist's honeymoon, and it is thought that the figures in the boat are Friedrich and his wife Caroline. Here he introduces a device that was still unusual in early nineteenth-century art: presenting the composition as if cut across the lower edge of the canvas. Thus the spectator is drawn right into the picture, being made to feel almost as if he is standing on the deck himself and is able to share the thoughts and emotions of the characters depicted on the canvas.

The Hermitage paintings by Caspar David Friedrich were probably acquired through the mediation of the poet Vasily Zhukovsky. In a letter of 1821, sent to Empress Alexandra Feodorovna from Dresden, he wrote: 'I found in his [Friedrich's] studio several unfinished pictures; one of them you might possibly like to have... it shows a return to their homeland of those seen leaving it in your picture.' The painting in question is the Hermitage's *Moonrise over the Sea*.

Caspar David Friedrich
1774–1840
Germany
On Board a Sailing Ship, 1818–20
Oil on canvas, 71 × 56 cm
From the Central Art Museums
Fund, Pavlovsk, 1945; previously
in the 'Cottage Palace', Peterhof

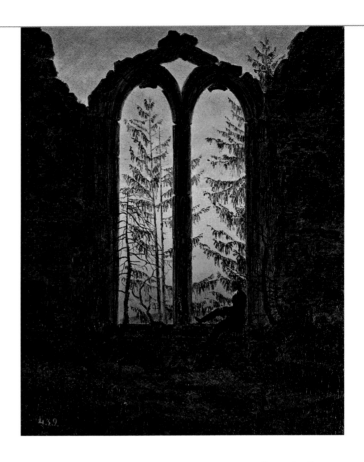

Caspar David Friedrich
1774–1840
Germany
The Dreamer (*Ruins of the Oybin Monastery*)
Oil on canvas, 27 × 21 cm
From the Nicholas II
collection in the Anichkov
Palace, St Petersburg, 1918

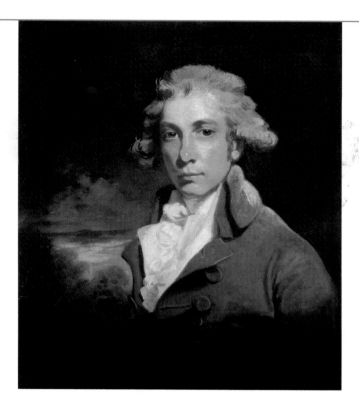

John Hoppner
1758–1810
England
*Portrait of Richard Brinsley
Sheridan?*
Late 1780s–early 1790s
Oil on canvas. 77 × 64 cm
From the Alexei Khitrovo
bequest, St Petersburg, 1912

Joseph Wright of Derby
1734–97
England
The Forge, 1773
Oil on canvas. 105 × 140 cm
Bought from the artist in
1774

(Left) A disciple of Reynolds and a rival to Lawrence, Hoppner was an extremely professional painter of portraits, but was more comfortable following a popular and successful pattern established by others than seeking to create something new. Works such as this, however, reveal a quick ability to capture the appearance and character of a sitter. A certain likeness with a portrait of Richard Brinsley Sheridan (1751–1816) by Joshua Reynolds led experts to suggest, although without absolute certainty, that the subject was the famous playwright, politician and orator. However, the costume and wig the sitter wears here belong to the fashion of the late 1780s, early 1790s; Sheridan would have been forty years old and many agree that the man portrayed here looks much younger. Regardless of his precise identity, however, it is clear he is a representative of Britain's intellectual elite, one of those who formed public opinions and tastes.

(Right) The romantic trends typical of late eighteenth-century English art found their most vivid reflection in the work of Joseph Wright of Derby. Between 1771 and 1773 Wright painted five pictures of an iron forge, of which this was the last. It was also the first of his paintings Catherine the Great acquired for the Hermitage. Later on, she bought two more pictures from Wright, who was extremely proud of her patronage. Curiously, the artist was virtually unknown on the Continent but his works, full of mysterious lighting effects and bold contrasts with shadow, found many admirers in Russia as the epitome of the English world perception. Here the light of the furnace creates a magic circle, warming and uniting the figures, in stark contrast with the frightening darkness of the night and the cold, pale, light of the moon.

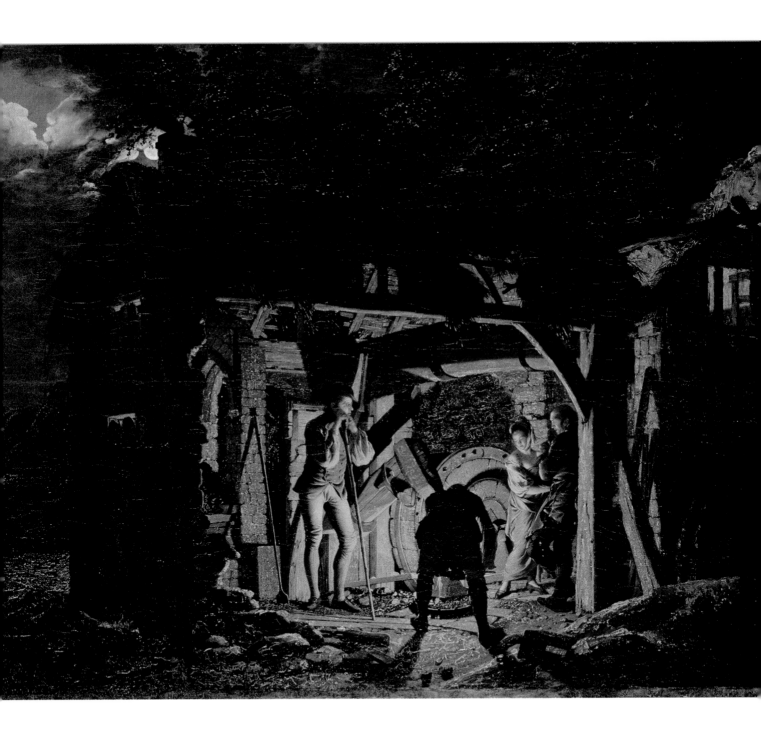

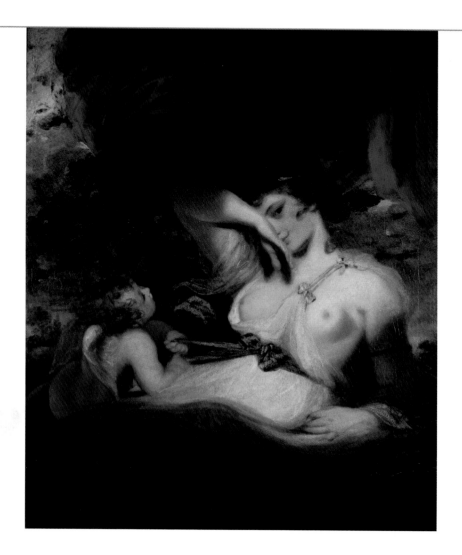

The Hermitage canvas of *Cupid Untying the Zone of Venus* is a replica of a well-known picture by Reynolds, painted for Lord Carysfort in 1784 and now in Tate Britain, London. Carysfort, who visited Russia on a number of occasions, asked the artist to make the copy as a gift for Prince Grigory Potemkin, and the picture was initially known as *Seated Venus, Playing with the Cupid Pulling at Her Dress*. In 1792, after acquiring the Potemkin collection, Catherine II ordered that the picture be entered in the Hermitage catalogue as the *Cupid Untying the Zone of Venus*.

In this work of charming but sensuous intimacy – Reynolds originally suggested it should be called *Half Consenting* – the goddess of beauty and love, Venus, is a coquettish young woman, hiding her face from immodest glances with her arm. Mischievous Cupid is pulling at the end of the blue silk ribbon which encircles her waist, looking attentively up at his mother to watch her reaction. It is possible that the model for the original painting was Emma, Lady Hamilton, famous as the mistress of Lord Nelson.

Joshua Reynolds
1723–1792
England
*Cupid Untying the
Zone of Venus*, 1788
Oil on canvas, 127 × 101 cm
Commissioned by Lord
Carysfort and presented
to Grigory Potemkin in
1788; the picture entered
the Hermitage in 1792

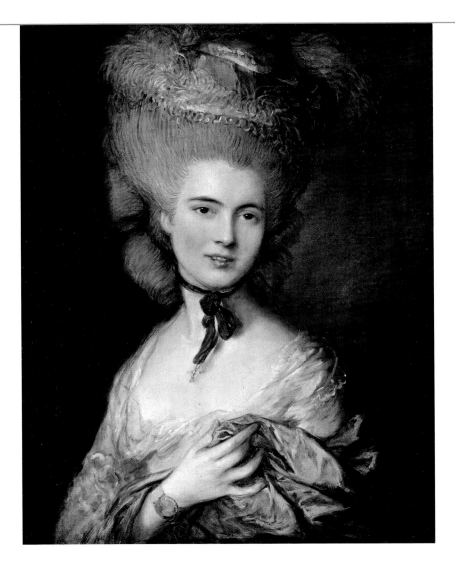

Thomas Gainsborough
1727–88
England
*Portrait of a Lady
in Blue*, late 1770s
Oil on canvas, 76 × 64 cm
From Alexei Khitrovo's
bequest, 1912

Gainsborough's heart was in landscapes but, ironically, he is mainly remembered for the portraits he had to produce to earn a living. Essential changes in English painting – especially in portraiture, the leading genre throughout the seventeenth and eighteenth centuries – took place under the influence of Anthony van Dyck. Van Dyck worked for a long time in London and produced most of his finest grand portraits there. Many English painters subsequently studied the style of the Flemish artist, seeking to emulate its refinement; Thomas Gainsborough was among them, however he went on to develop a much-admired style that would set him apart from his contemporaries, applying very fluid paints in a semi-transparent layer, with fine brushes. Even his great rival, the first president of the Royal Academy, Sir Joshua Reynolds, admitted his skill: "All those odd scratches and marks which, on a close examination, are so observable... and which even to experienced painters appear rather as the effect of accident than design: but this chaos, by a kind of magic, at a certain distance assumes form..."

This, the only work by Gainsborough in the Hermitage, is amongst the most beautiful English portraits ever painted. Gainsborough created an image of great elegance and beauty, dominated by a mood of romantic dreaminess. The light, mobile, melting brushstrokes convey the soft skin, the greyish-blue silk of the shawl, and the luxuriant feathers of the headdress which surmounts the powdered wig. Free, sketchy painting is combined with fine transitions of colour to create an effect something akin to pastel. The sitter was for a while supposed to be the Duchess of Beaufort. This identification was subsequently dropped for lack of documentary evidence, and who this beautiful woman was remains a mystery.

Thomas Lawrence
1769–1830
England
*Portrait of Emily Wellesley-Poul
(Lady Raglan)*, c.1814
Oil on panel, 76 × 63 cm
From the Alexei Khitrovo
bequest, St Petersburg, 1912

The Hermitage collection of sixteenth-
to nineteenth-century English painting
includes over 450 items and is of particular
importance, bearing in mind the rarity
of works by English artists in European
museums. It includes four works by
Thomas Lawrence.

A self-taught boy prodigy, Lawrence
became very early on a celebrated artist.
He is today remembered as the most
successful portrait painter in England
during the Romantic period, and the
most fashionable.

He first exhibited at the Royal Academy
when he was twenty years old, and was
appointed Painter to the King (George III)
on the death of Sir Joshua Reynolds two
years later. He was knighted in 1815 and,
in 1820, Sir Thomas became president
of the Royal Academy. He is mostly known
as a portraitist as he was commissioned
in 1814 by the Prince Regent – the future
King George IV – to paint all statesmen,
generals, sovereigns who were opposing
Napoleon and his campaigns (these
paintings now form the Waterloo Chamber
at Windsor Castle).He became so well
known and was in such great demand that
he could afford to only paint the rich, royal
and famous, whether members of British
high society, such as Lady Raglan (left), or
the Russian nobility, who were travelling or
living abroad, like Count Mikhail Vorontsov
(right).

Thomas Lawrence
1769–1830
England
*Portrait of Count Mikhail
Vorontsov*, c.1821
Oil on canvas, 143 × 113 cm
From the Vorontsov-Dashkov
collection, St Petersburg, 1920

INDEX OF ARTISTS